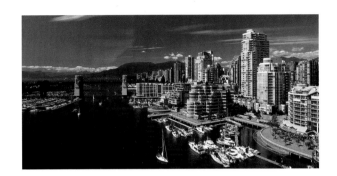

VANCOUVER

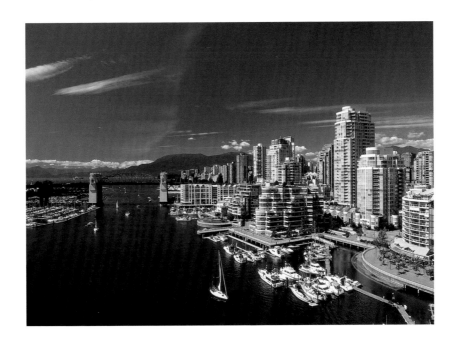

WHITECAP BOOKS

The information in this book is true and complete to the best of our knowledge. All
recommendations are made without guarantee on the part of the author or Whitecap
Books Ltd. The author and publisher disclaim any liability in connection with the use
of this information. For additional information please contact Whitecap Books Ltd.,
351 Lynn Avenue, North Vancouver, British Columbia, Canada, V7J 2C4

Text by Tanya Lloyd
Edited by Elaine Jones
Photo editing by Pat Crowe
Proofread by Lisa Collins
Cover layout by Roberta Batchelor
Book layout by Steve Penner
Front cover photograph by Kevin Miller
Back cover photograph by Ken Straiton/Firstlight

Printed and bound in Canada

National Library of Canada Cataloguing in Publication Data

Lloyd, Tanya, 1973–
 Vancouver

 (Canada series)
 ISBN 1-55110-528-4 (bound).—1-55285-592-9 (pbk).

 1. Vancouver—Pictorial works. I. Title. II. Series:

Lloyd, Tanya, 1973.
FC3847.37.L66 1997 971.1'3304'0222 C96-910735-8
F1089.5.V22L66 1997

The publisher acknowledges the financial support of the Government of Canada through
the Book Publishing Industry Development Program for our publishing activities.

> **For more information on the Canada Series and other Whitecap Books**
> titles, please visit our web site at www.whitecap.ca.

Ask visitors to describe Vancouver: they'll tell you about the strings of lights along the Lions Gate Bridge, the world-class architecture of the downtown core, or the natural haven of Stanley Park. These are the images that have made the city a destination for travellers from every continent—more than seven million each year.

But between the grandeur of the old-growth trees and the mirrored glass high-rises lie the details and diversities that continue to enthral the locals. In Vancouver, you can walk between the delicate landscapes at Nitobe Garden and the awe-inspiring First Nations artwork at the Museum of Anthropology. You can sample barbecued duck in Chinatown or Okanagan apples at Granville Island Market. You can wander past the old-town buildings of Steveston or hike the mountains that tower behind the city.

This diversity comes in part from the city's tumultuous history. For thousands of years a traditional site for First Nations peoples, the area experienced rapid change and many transformations—mill town, fishing base, gateway to the gold rush—after European settlement. It began as a small cluster of buildings along Burrard Inlet, but the first transcontinental passenger train arrived in 1887 and ships were soon docking from every corner of the globe. By the turn of the century, 10,000 called Vancouver home.

Today, Vancouver remains the hub of British Columbia's industry. Logs lie ready for export in New Westminster, coal is sent around the world from Tsawwassen, and ships dock in Burrard Inlet to be filled with grain. But the city has also achieved international importance in the arts and commerce. Downtown studios host Malaysian executives and Californian movie producers. Businesses from Korea, Japan, and India have opened offices and forged partnerships with Vancouver firms.

The images in *Vancouver* capture the sights that make the area famous, and those that endear it to business people, artists, students, and labourers. The photographers have taken their cameras into the streets to find the people and places that define the city. In their work, you can discover the roots of Vancouver, and the energy that has made it a modern focal point of Canada and the Pacific Rim.

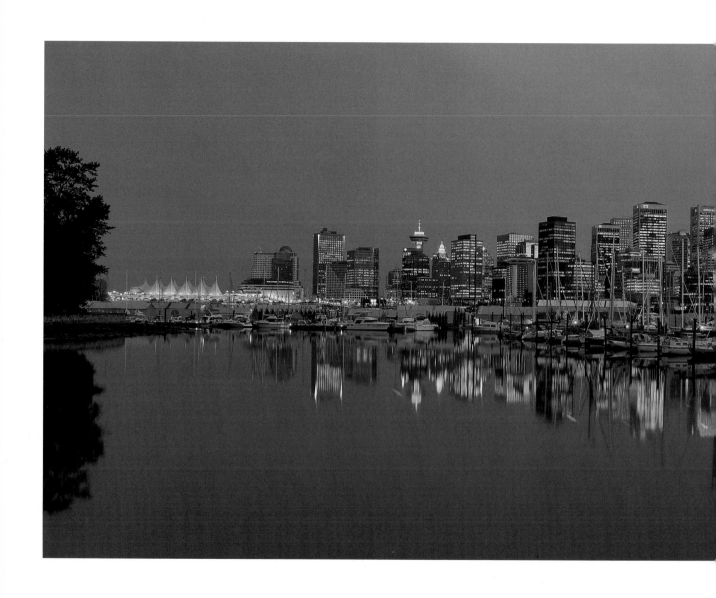

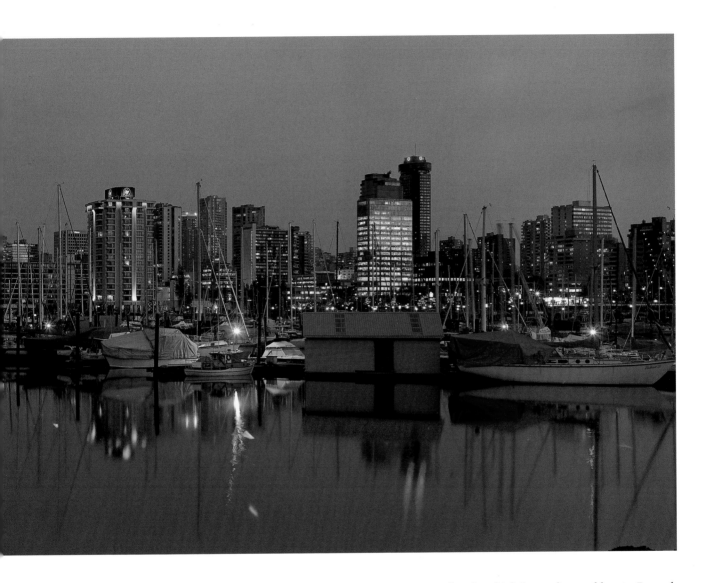

Canada's third–largest city, Vancouver is a stunning juxtaposition of modern highrises and natural beauty. Burrard Inlet forms the northern edge of downtown, and pleasure boats, cruise ships, and tankers stream through its waters.

Gastown's unique shops and restaurants make it a favourite with visitors. In Harbour Centre's tower, they can enjoy an eagle-eye view of both the neighbourhood and the city from the Top of Vancouver Revolving Restaurant.

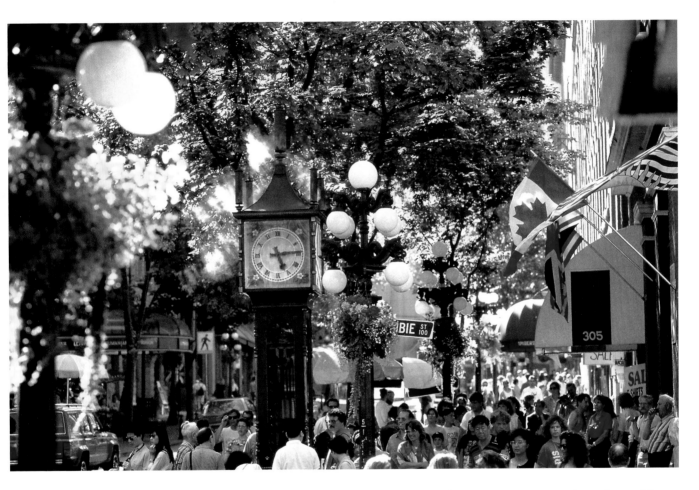

A crowd gathers on Water Street to hear the world's only steam-powered clock sound its hourly whistle. Operated by an underground system, the clock was built in 1977 by Raymond L. Sanders in celebration of historic Gastown's restoration.

John "Gassy Jack" Deighton is one of historical Vancouver's most colourful characters. The talkative riverboat captain settled in Vancouver in the late 1800s to open the city's first saloon.

FACING PAGE –
On the eastern edge of downtown, Victory Square is the site of Vancouver's annual Remembrance Day ceremony. The Dominion Building in the background was the city's tallest building when it was completed in 1909.

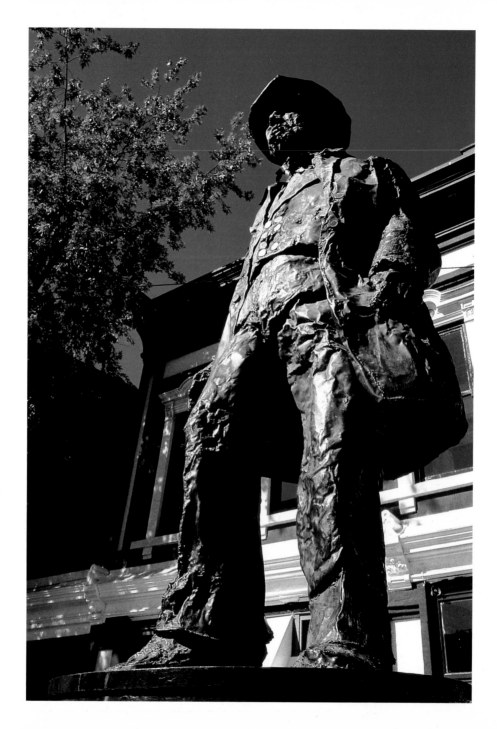

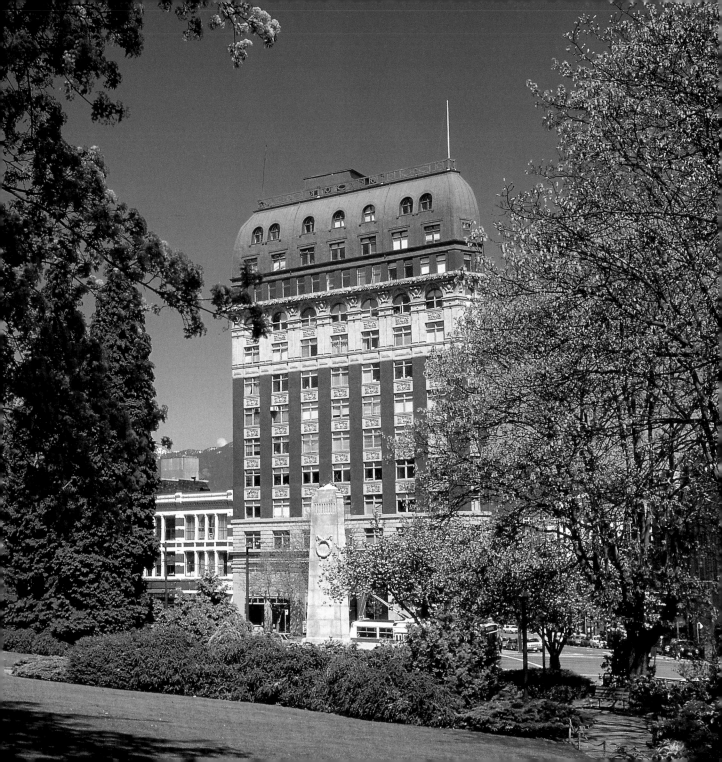

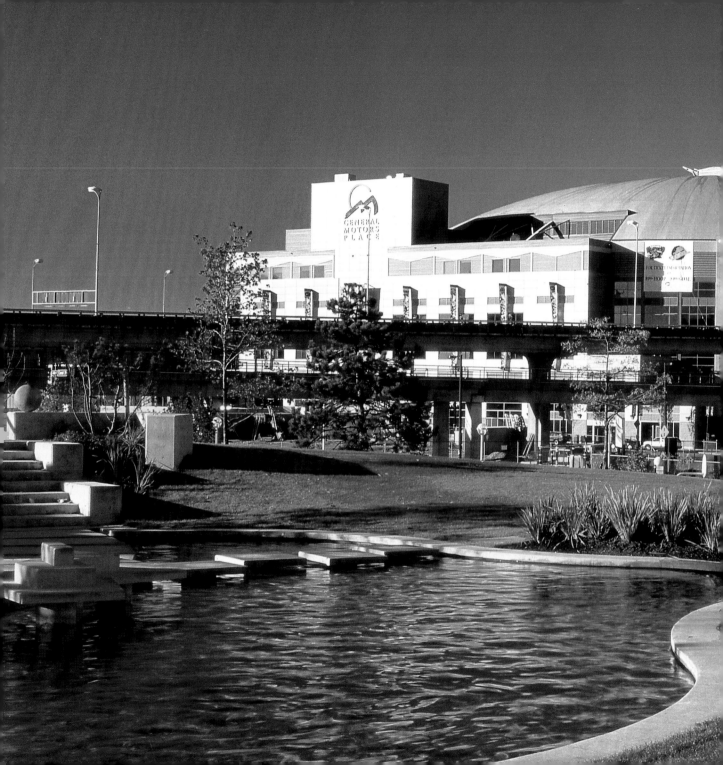

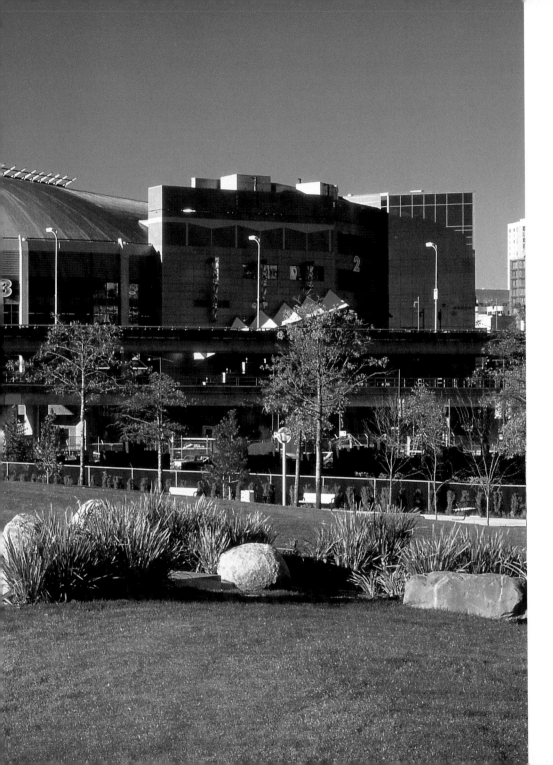

Fans cheer for the
home teams at
General Motors Place.

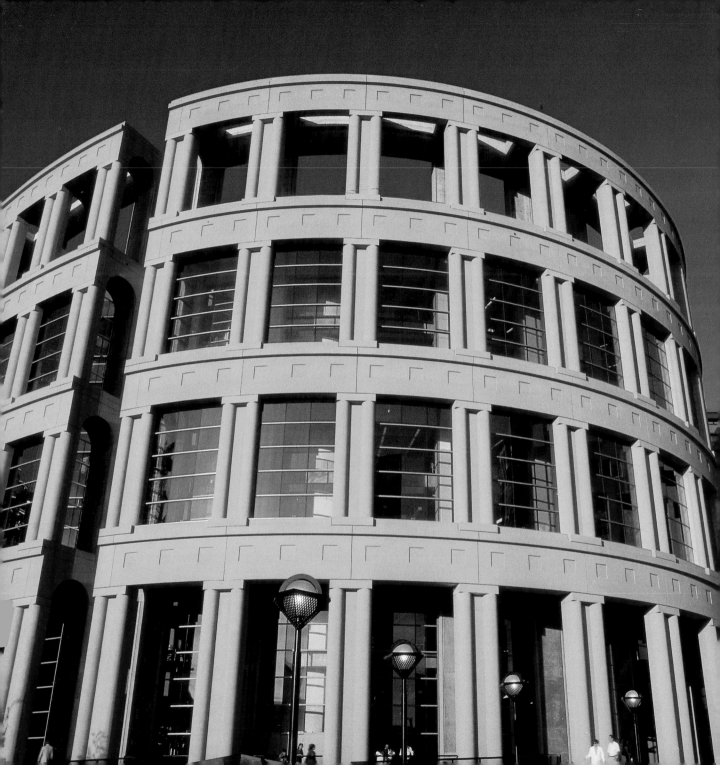

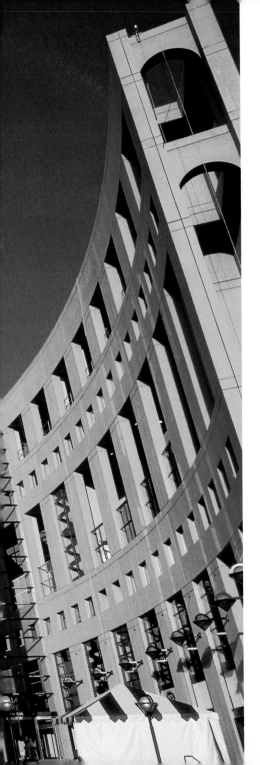

The sweeping curves of the Vancouver Public Library, designed by architect Moshe Safdie, draw visitors into a state-of-the-art facility. The building boasts extensive research tools, reading areas with natural light, and fibre-optical technology that can accommodate up to 800 computer terminals.

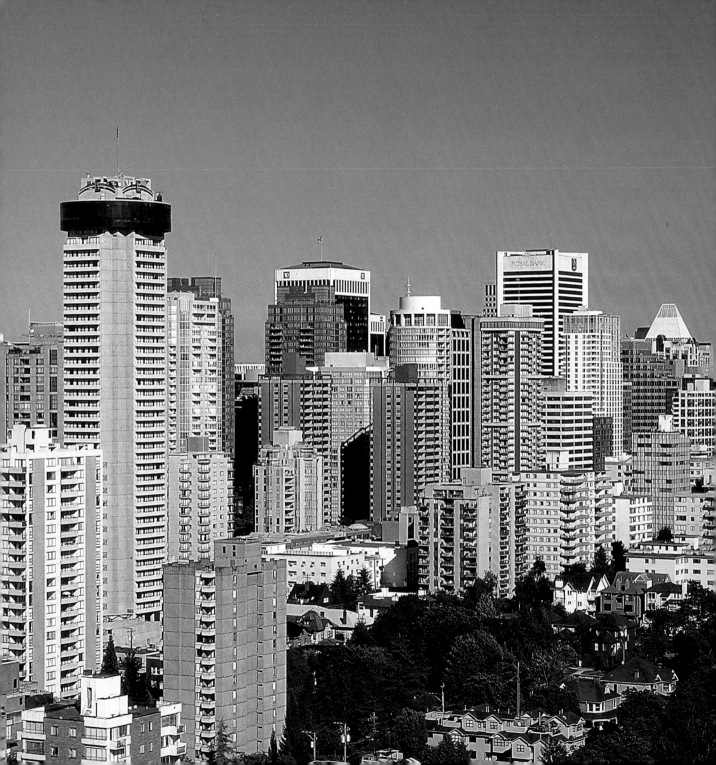

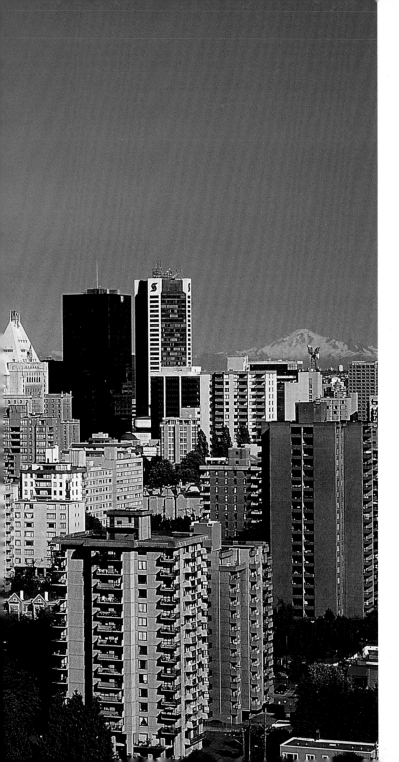

Along with the central business district, cultural attractions, and Robson Street's famous shops and restaurants, Vancouver's downtown core is also home to thousands of city residents. Hip neighbourhoods such as the West End, Yaletown, and Coal Harbour have created one of the fastest growing downtown populations in North America.

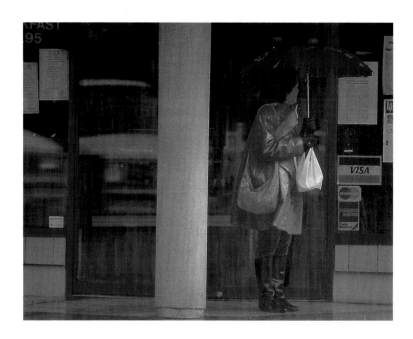

A woman ducks under
cover as a winter shower
drenches Robson Street.

The trendy Yaletown
district, a combination of
turn-of-the-century brick
warehouses and contem-
porary look-alikes, is often
used as a setting for tele-
vision shows and feature
films.

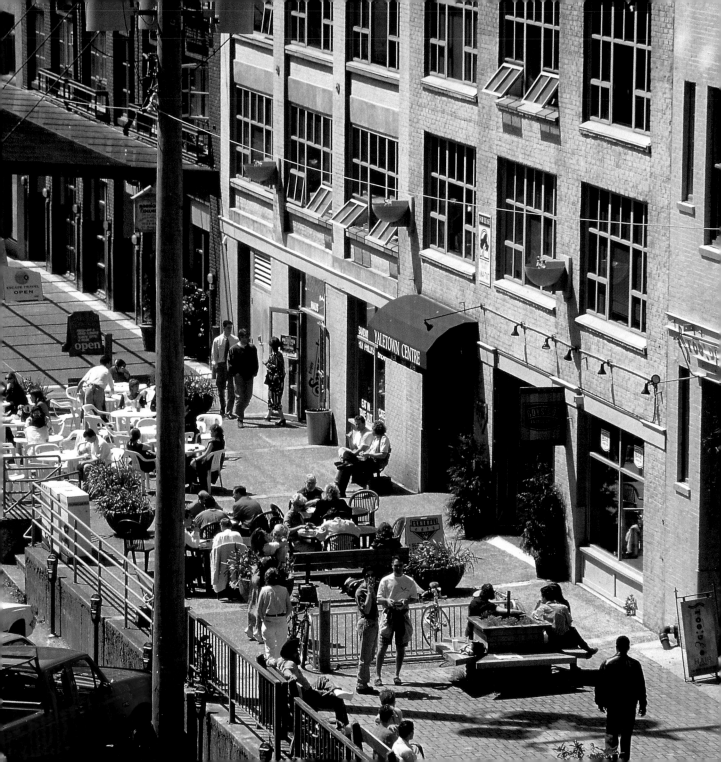

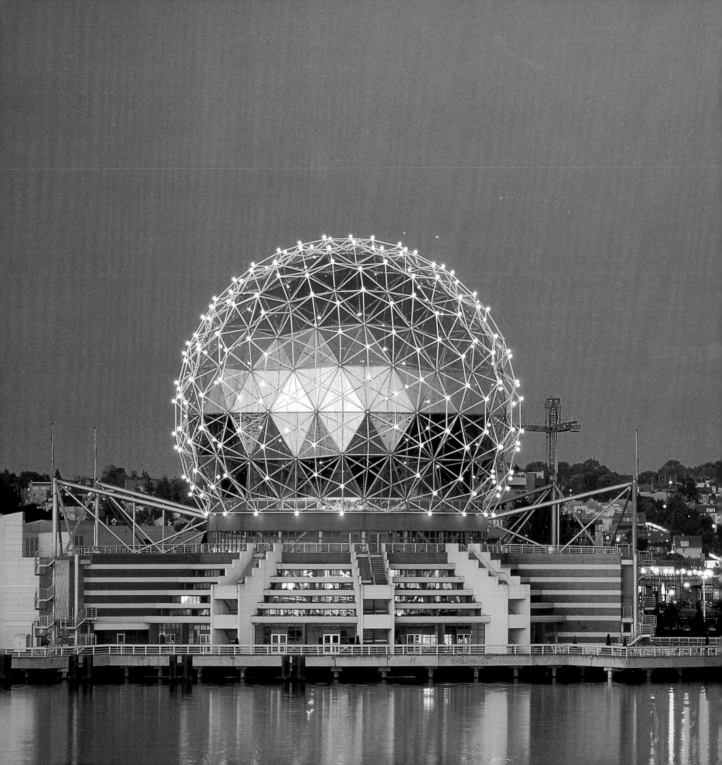

Built for the 1986 World Exposition, Science World is a landmark of the Vancouver skyline. Inside the space-age dome are hundreds of exhibits and hands-on displays. Its popular Omnimax Theatre is the largest domed theatre in the world.

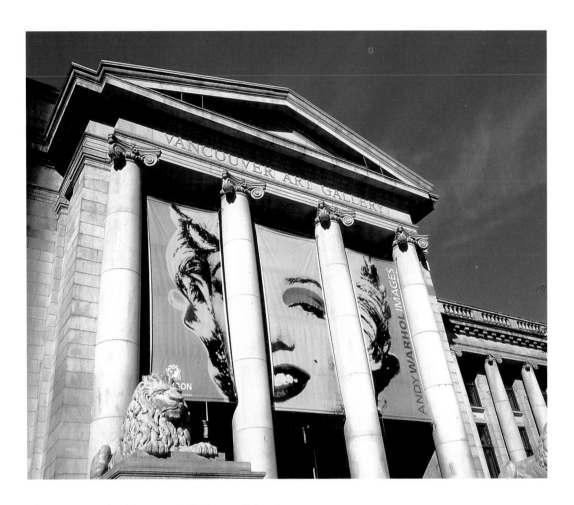

This imposing building originally housed the city courthouse. Now, it is the Vancouver Art Gallery and home to an extensive collection, including many of the paintings of British Columbia artist Emily Carr.

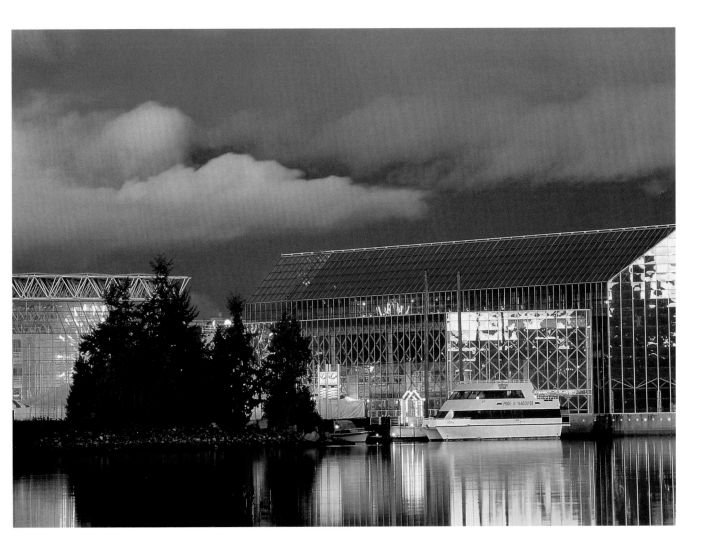

Hosting everything from scientific conferences to high-energy rock concerts, The Plaza of Nations is one of the city's most popular convention and special-event sites.

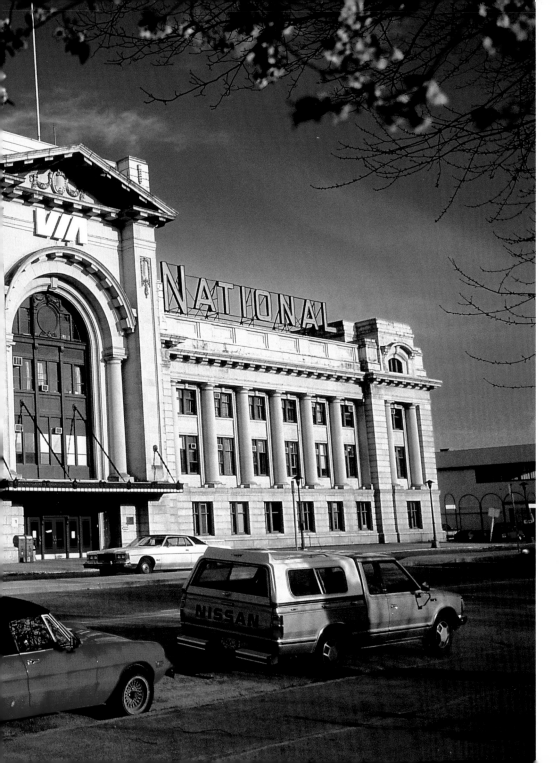

Originally built in 1919 as the terminal for Canadian Northern Railways, the restored station now serves passengers of several bus and rail lines.

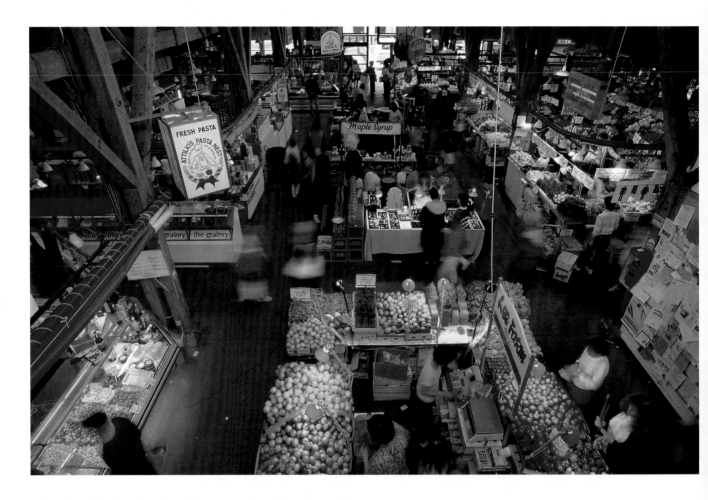

The Granville Island Market offers everything from live crabs to handmade chocolates, making it a favourite weekend destination for both tourists and residents.

Sailboats crowd the docks of the Granville Island marina. Close to both the city and the open water, this is an ideal base for boating.

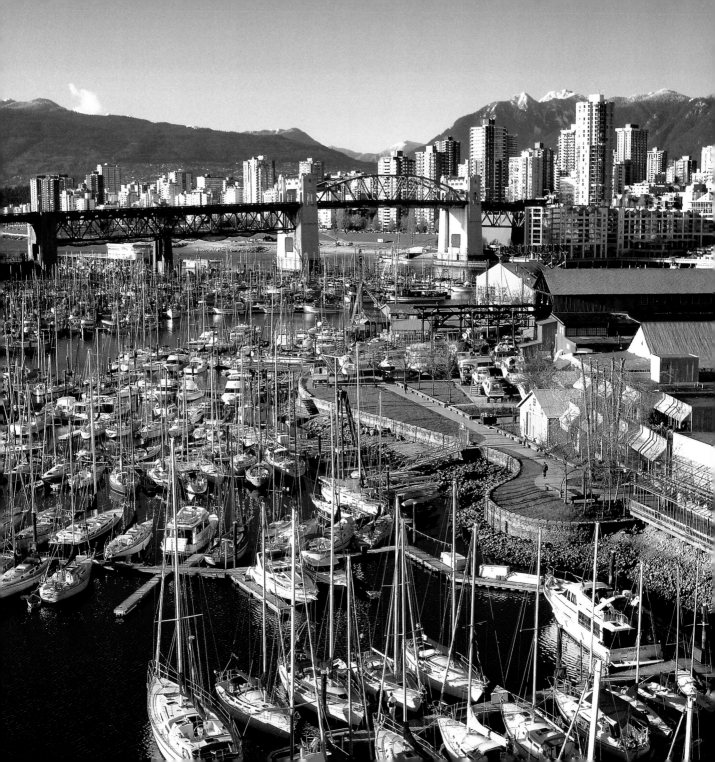

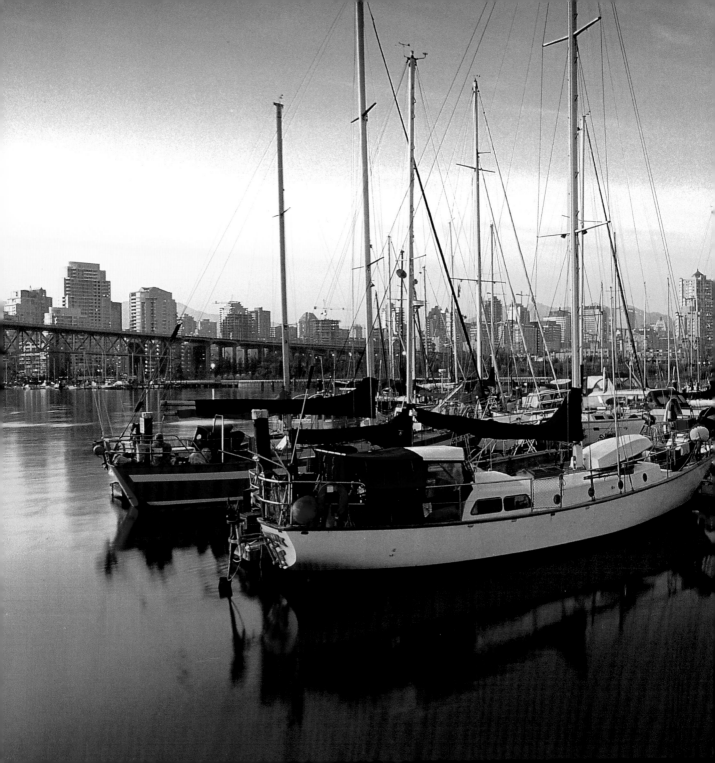

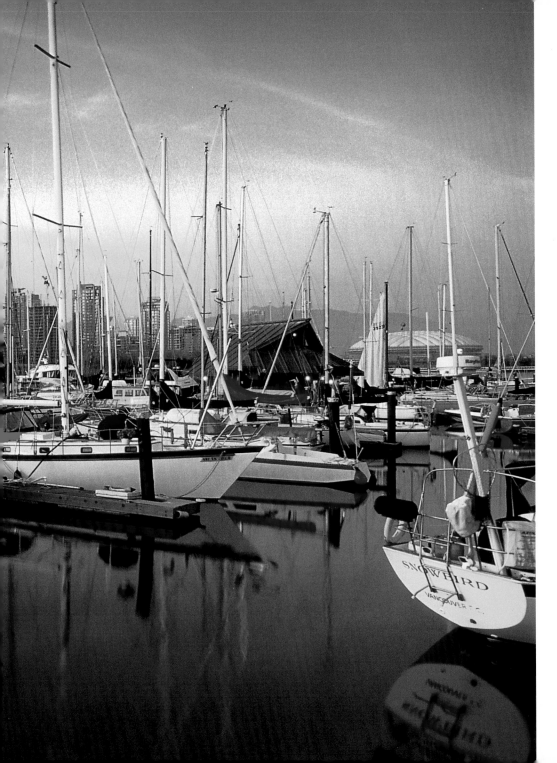

Once an industrial basin, False Creek now shelters up-scale housing developments, parks, a picturesque seawall, and a marina. This "creek" is actually an inlet, mistakenly named by Captain George Richards in 1859.

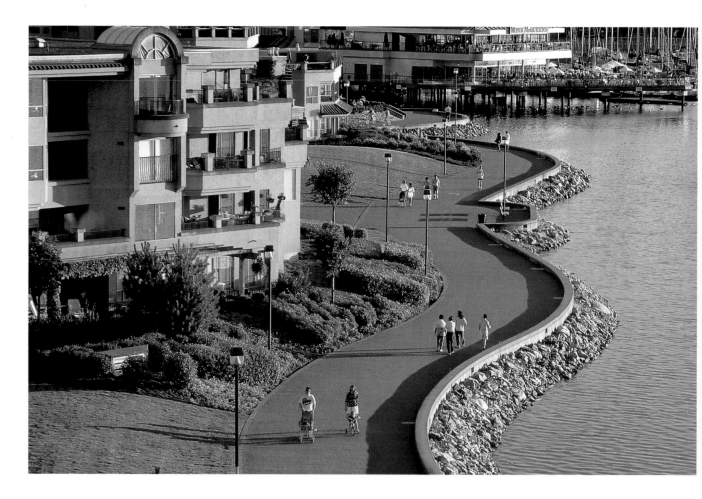

A popular route for runners and cyclists, the False Creek seawall
stretches from the Cambie Street Bridge to Granville Island.
Until recently, False Creek was a mainly industrial area, home to the
CPR railyard. The rails were removed to prepare for the 1986
World Exposition, an event that brought millions of visitors to the city.

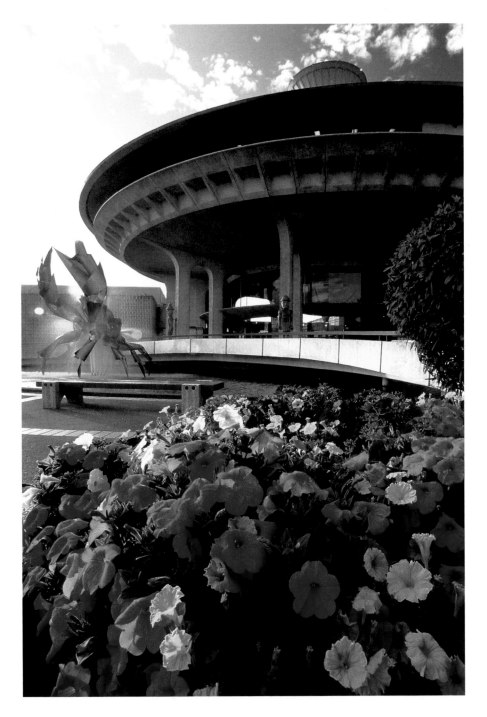

Daytime astronomy shows and evening rock 'n' roll laser displays draw crowds to the H.R. MacMillan Planetarium in Vanier Park.

Beautifully land-scaped Queen Elizabeth Park was once the site of rock quarries that supplied stone for the city's first roads. Under the Bloedel Conservatory's dome, where jungle and desert flourish side by side, visitors wander past tropical birds, palm trees, and cacti.

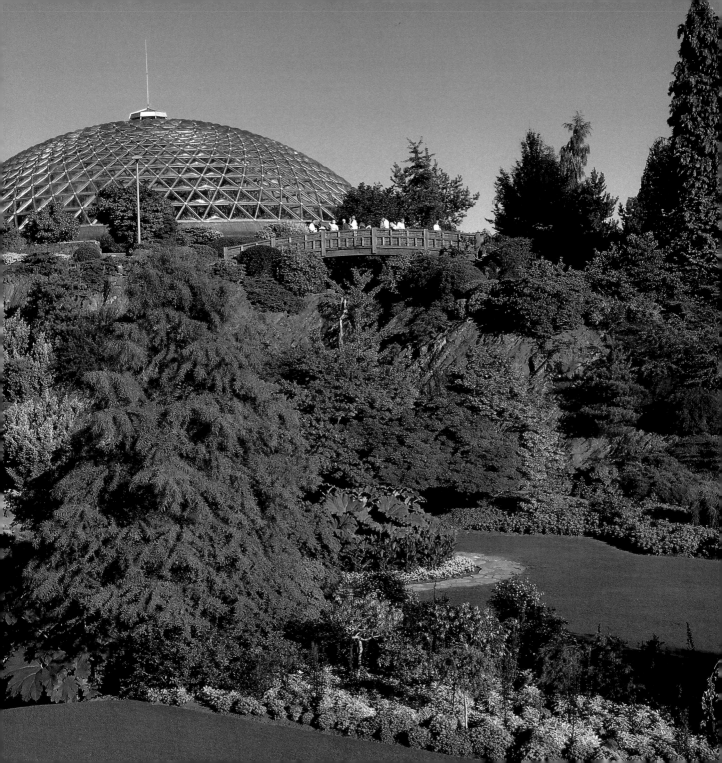

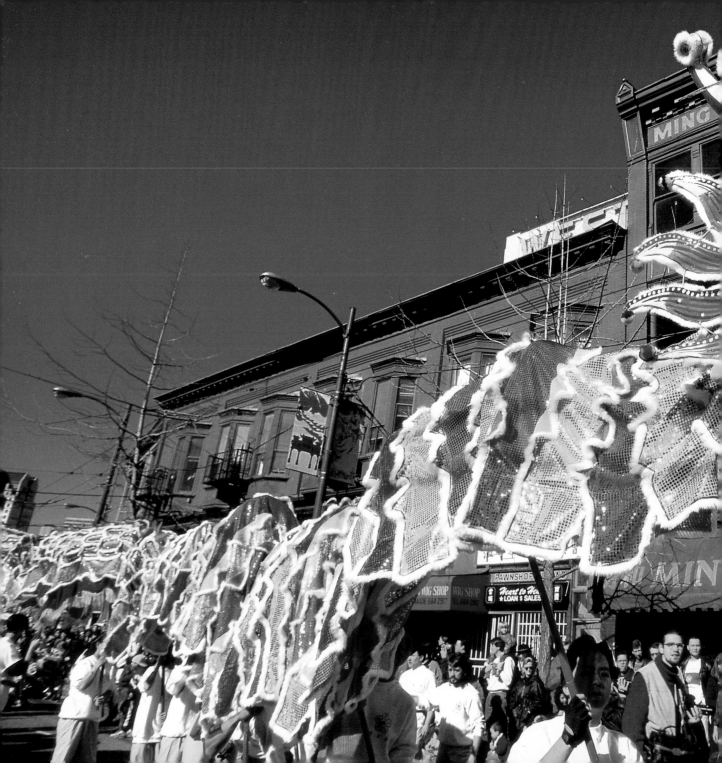

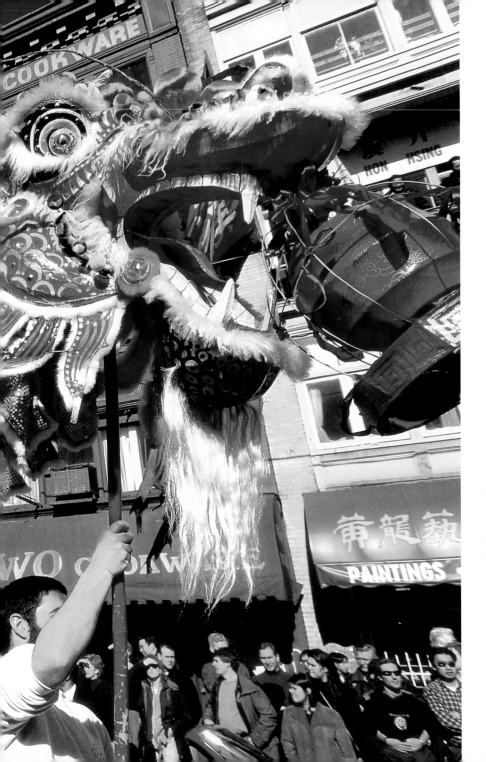

This colourful dragon is part of Chinese New Year festivities, held in late January or early February. The new year is celebrated throughout the city, but activities centre in Chinatown, where a huge and boisterous parade draws thousands of spectators.

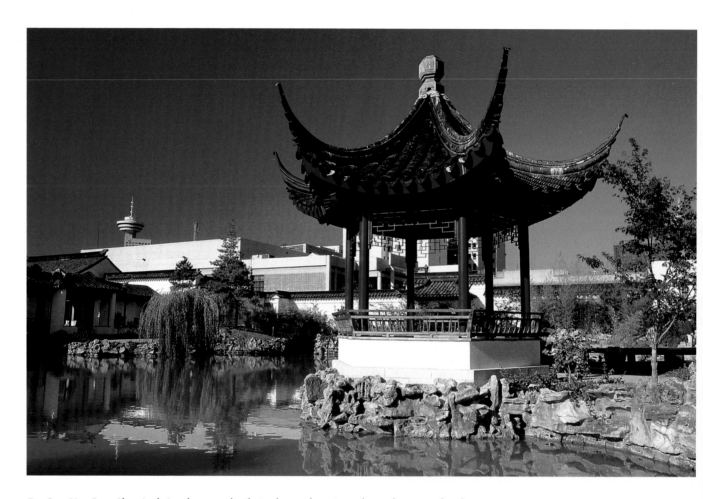

Dr. Sun Yat-Sen Classical Garden was built in the authentic style and materials of the Ming Dynasty (1368-1644), with the aid of 52 artisans from Suzhou, the Garden City of China. Traditionally, gardens such as this one were places for scholars to live and work. This garden and the public park next to it are named in honour of Dr. Sun Yat-Sen, a Chinese reformer who visited Vancouver in 1906.

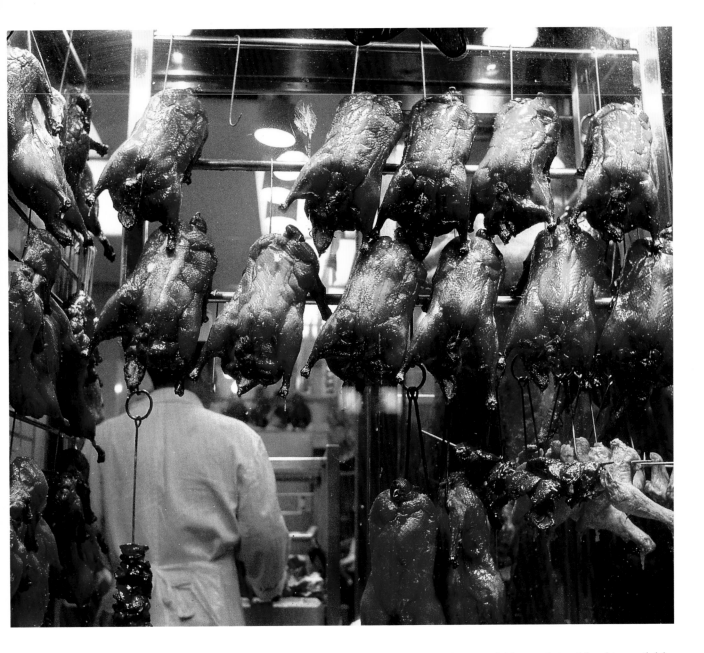

An astonishing variety of food is available in Vancouver's vibrant Chinatown, the second largest in North America.

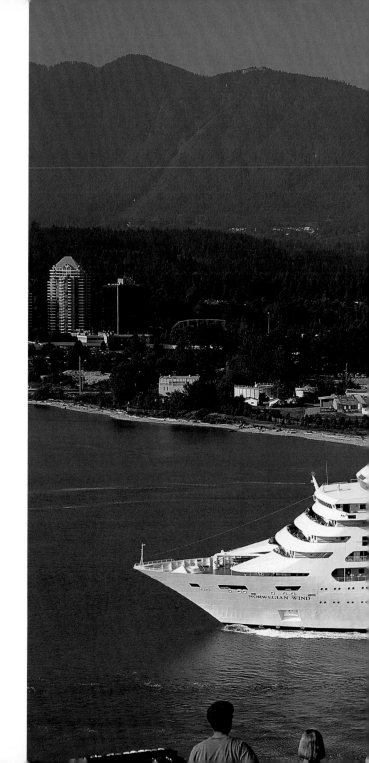

A cruise ship steams under the Lions Gate Bridge. Each year, Vancouver hosts more than 300 cruise ships and about one million passengers. Most are bound for Alaska.

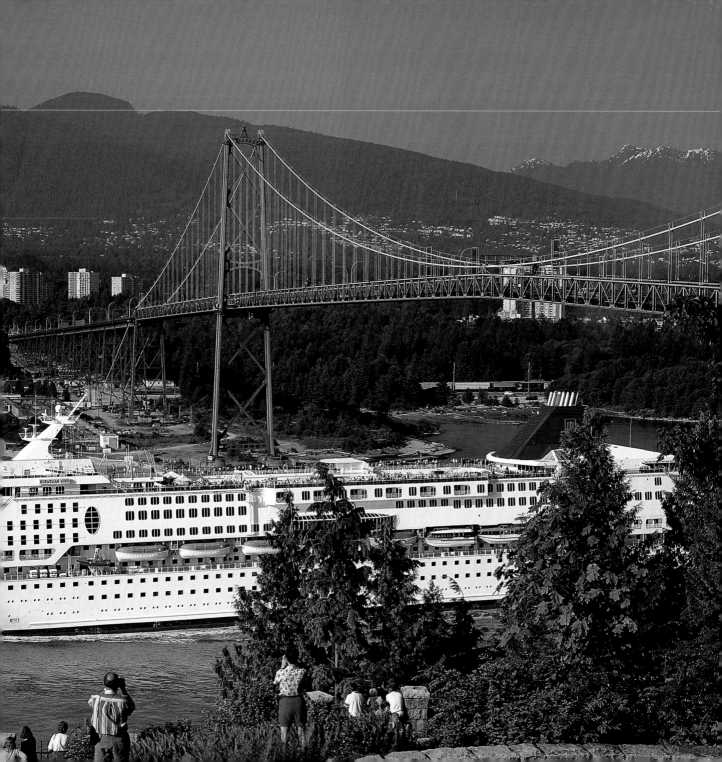

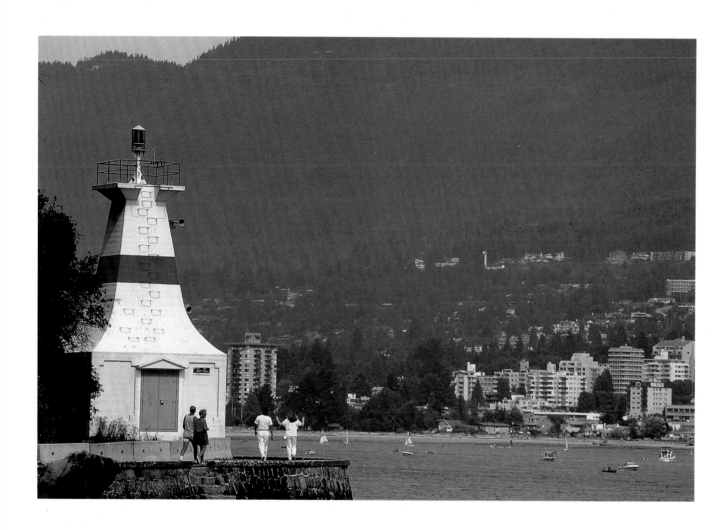

One of many sights along Stanley Park's seawall, the lighthouse at Brockton Point was built
in 1915 to help guide vessels into Burrard Inlet. The first
lighthouse at this location was completed in 1890.

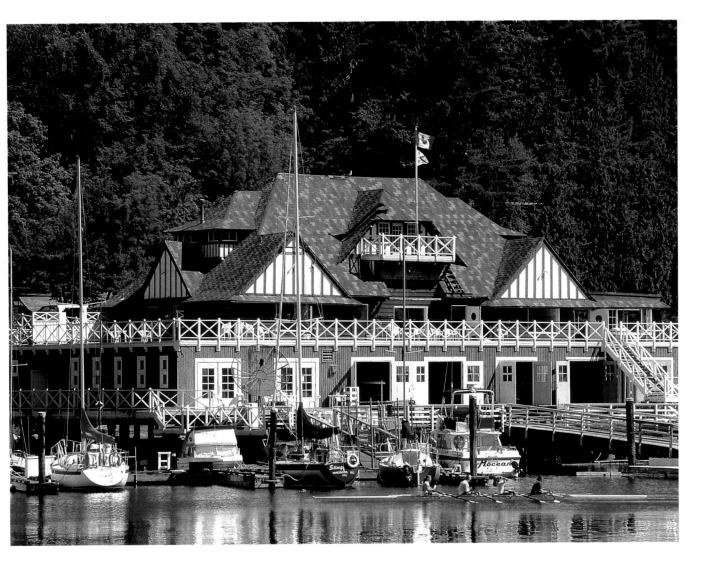

Rowers glide away from the dock at the Stanley Park Rowing Club.

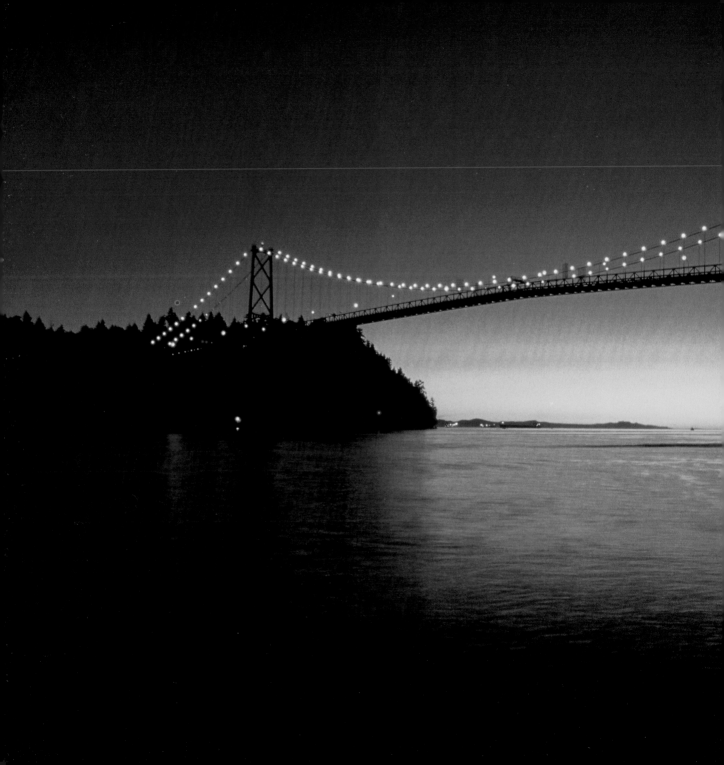

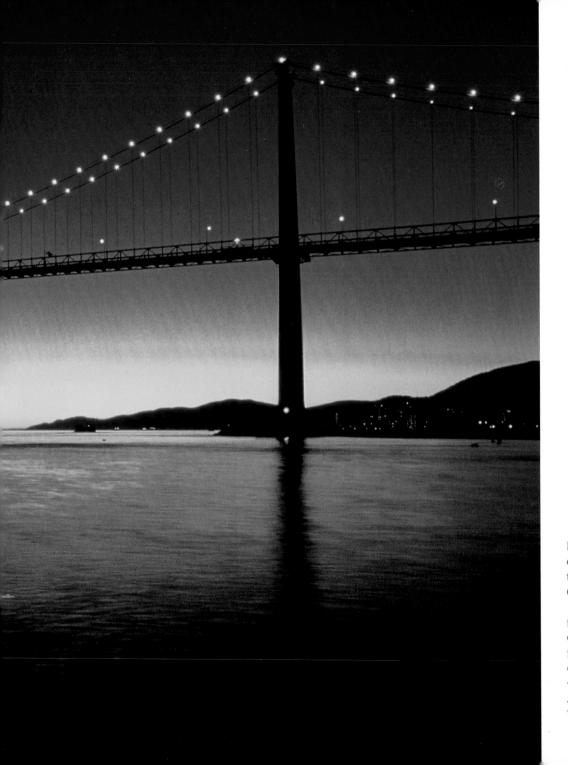

Hundreds of lights outline the cables of the Lions Gate Bridge. Officially opened in 1939, the bridge was financed by the Guinnesses (the same family known for Guinness beer), who wanted to increase access to their land in West Vancouver.

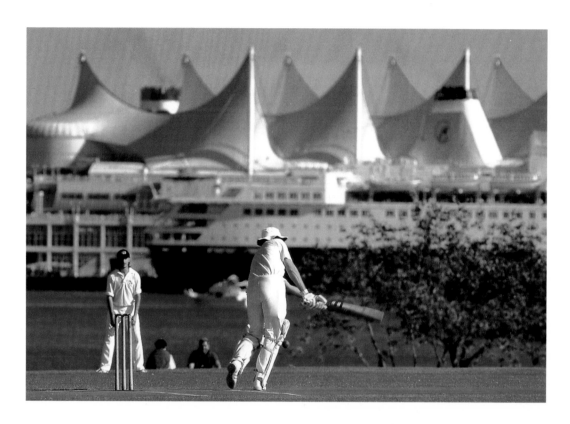

Running, cycling, in-line skating–the park is a 405-hectare recreation playground in the city's centre. Sports enthusiasts like these cricket players find ample room to play along the park's northern edge.

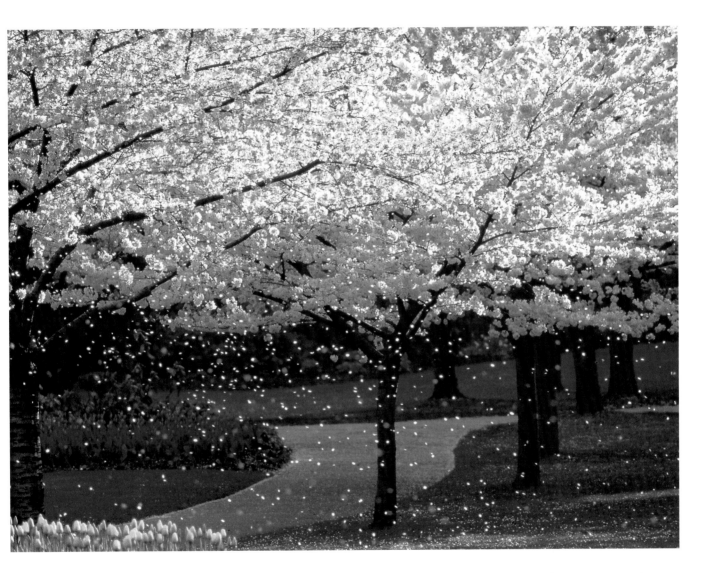

Spring brings a snow of cherry blossoms in Stanley
Park and streets throughout the city.

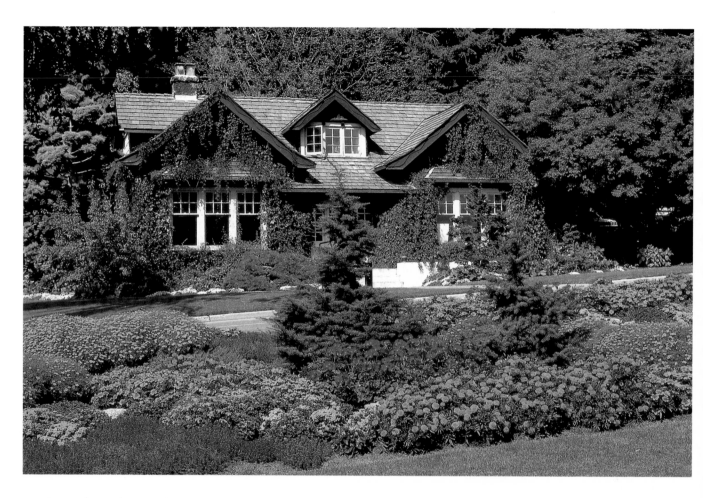

Stanley Park's Tudor-style buildings are draped in wisteria and surrounded by flowers and greenery.

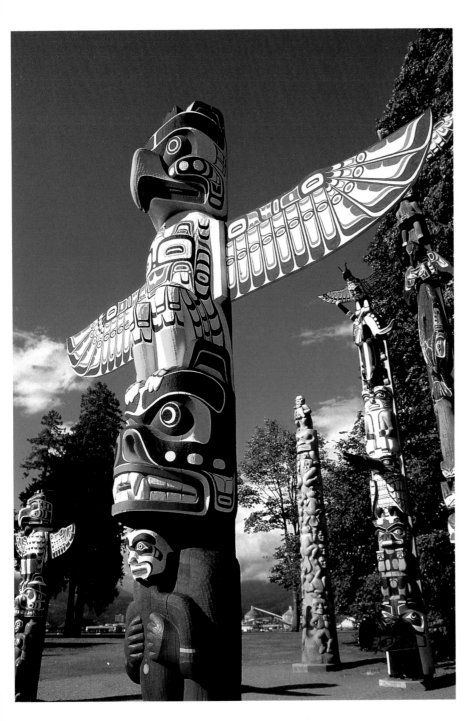

Intricately carved birds and animals mark the totem poles at Brockton Point in Stanley Park. The first poles by British Columbia's First Nations artists were raised at Brockton Point at the turn of the century.

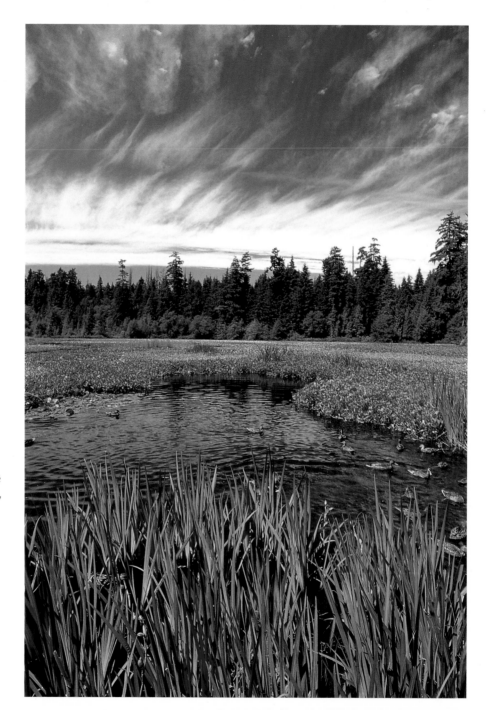

Ducks swim among the cattails of Beaver Lake, a natural pond in the park.

The seawall, which encircles much of the park, stretches for ten kilometres along the shore.

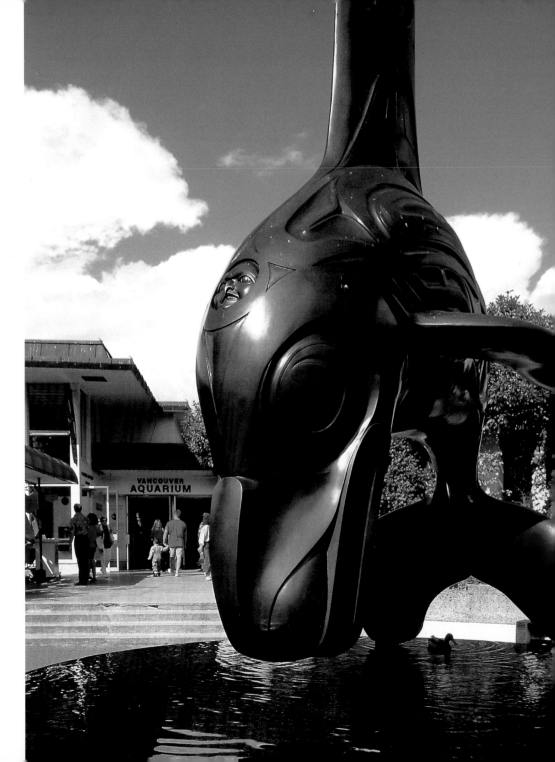

This bronze orca greets visitors to the Vancouver Aquarium. The 5.5-metre sculpture is the work of British Columbia artist Bill Reid.

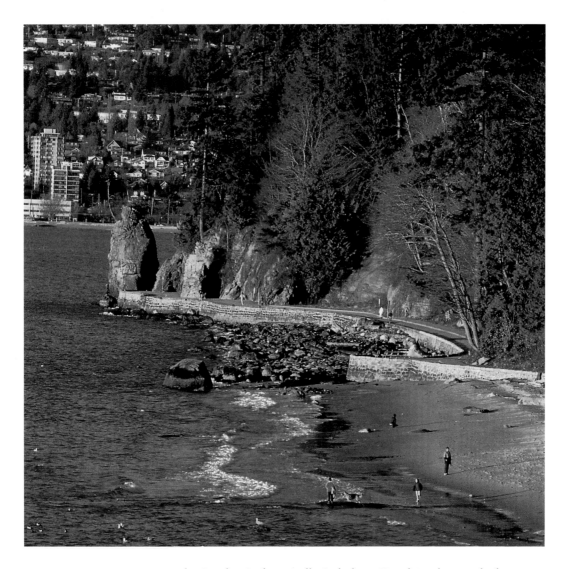

The Stanley Park seawall winds from Siwash Rock towards the beach, where a few brave walkers test the waves. According to First Nations' legends, the looming Siwash Rock at the tip of the point was once a young man. He was made immortal because of his devotion to the gods.

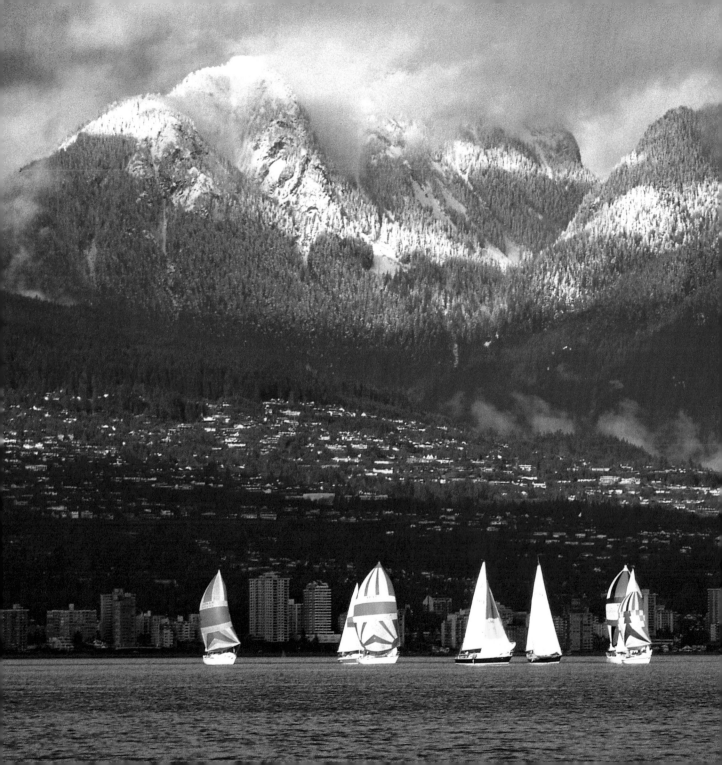

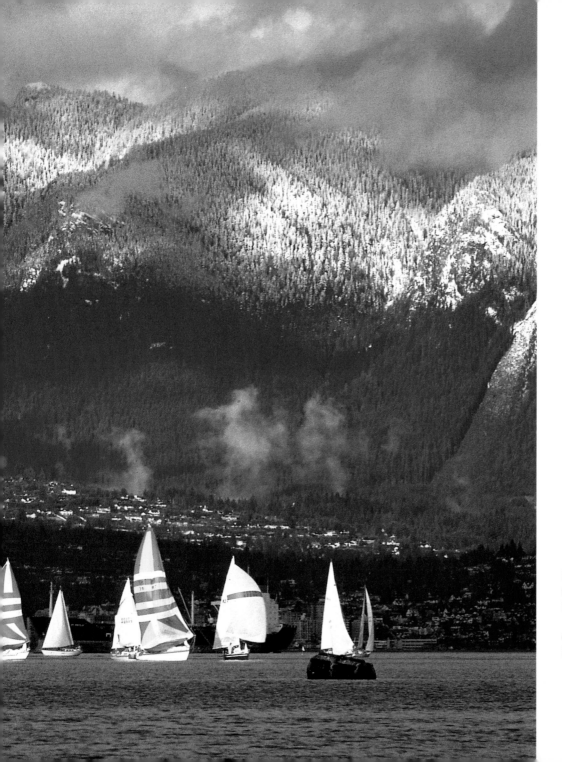

Boats spread their sails near Spanish Banks, named for the 1791 visit of Spanish explorer Jose Maria Narvaez.

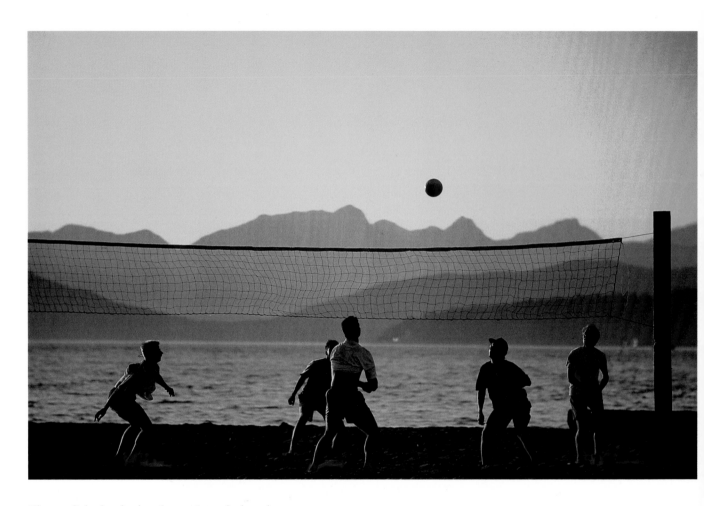

Players fight for the last few points of a beach
volleyball game as the sun sets behind them.

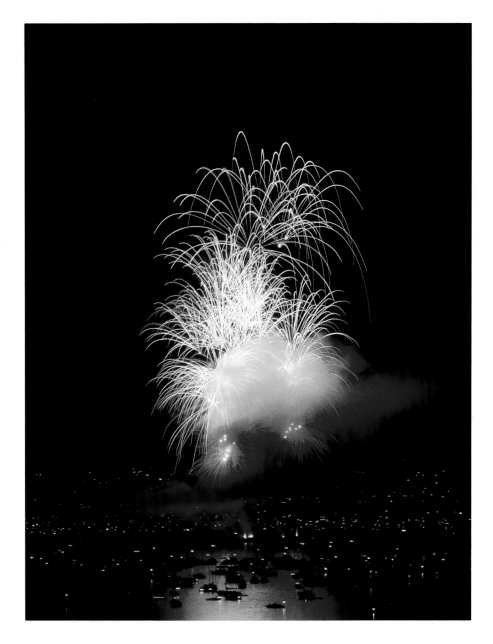

Spectators line the shore and boaters crowd the waters of English Bay to watch as a giant pyrotechnic display lights up the sky.

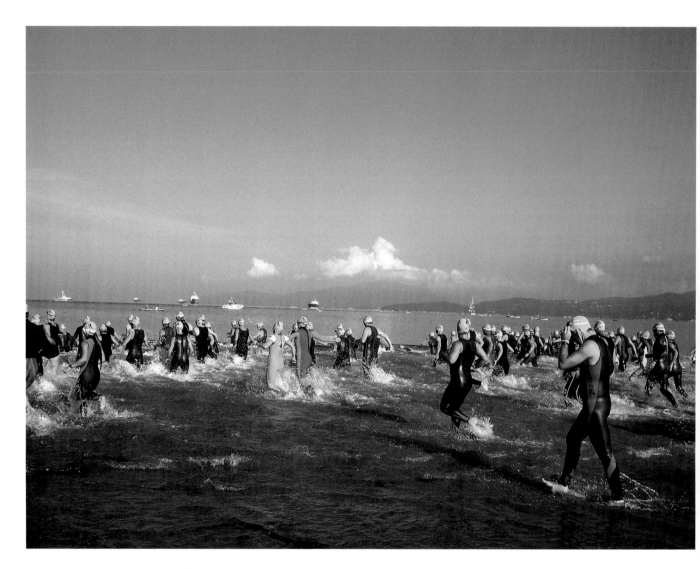

Vancouver International Triathlon competitors splash
their way from the starting line into the ocean.

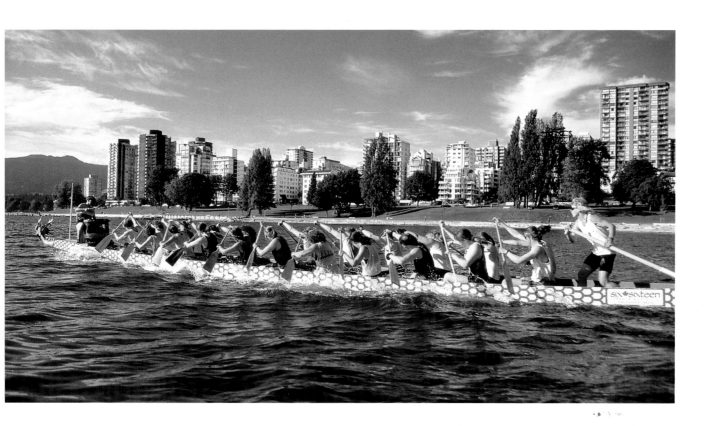

Following a Chinese tradition 2000 years old, the False Creek women's dragon boat team practises in English Bay for international races in Hong Kong. Vancouver has its own dragon boat festival each June on the waters of False Creek.

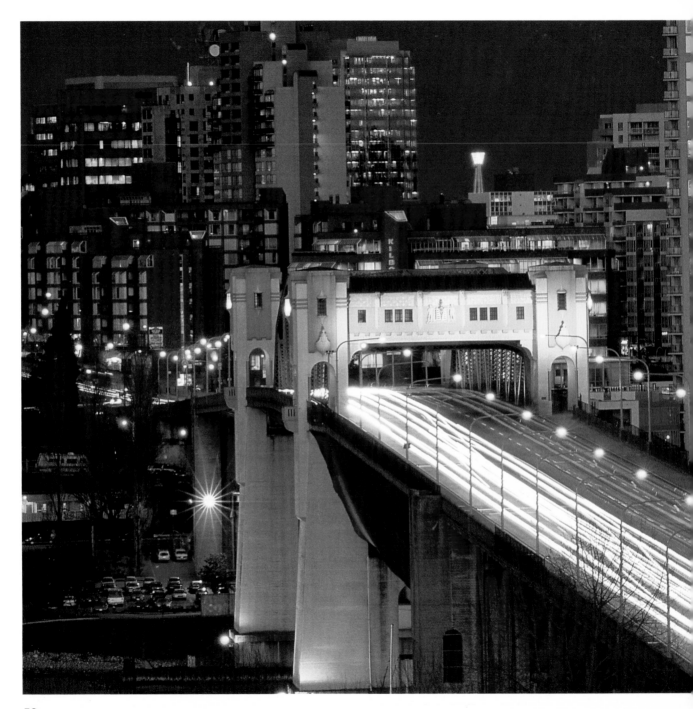

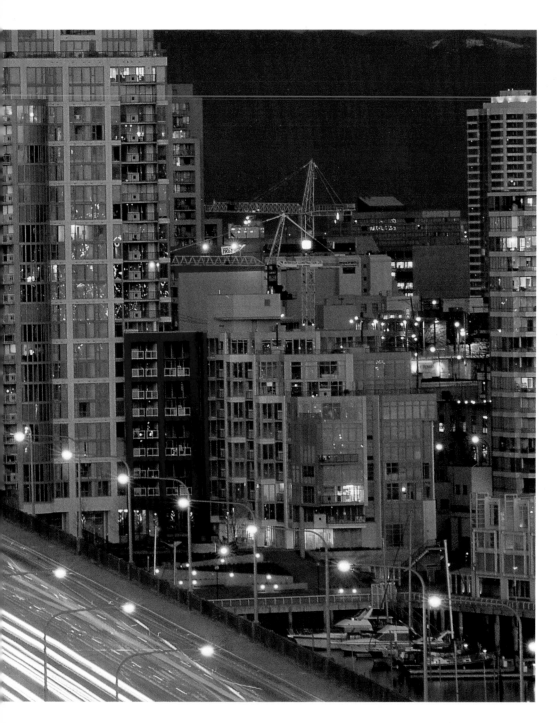

The Burrard Street Bridge is a busy corridor for traffic streaming into and out of downtown. Built in 1932, it was Vancouver's first high bridge.

Swimmers cool off in Kitsilano's saltwater pool, with the downtown skyline in the background.

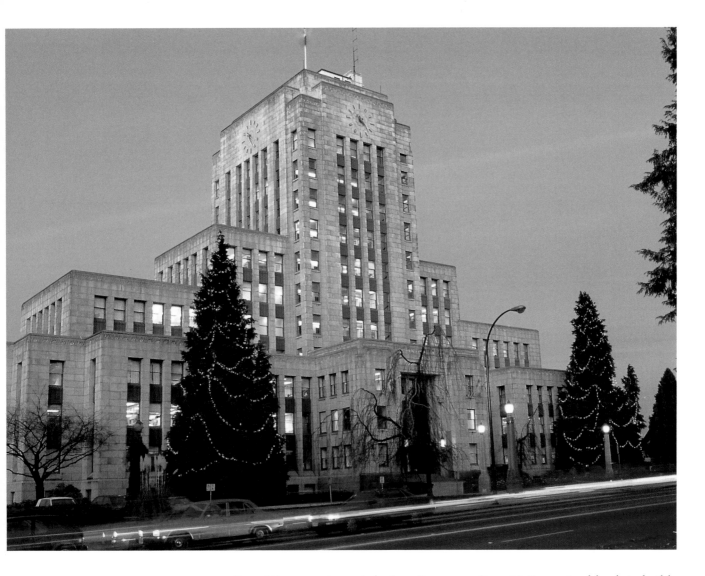

One of Vancouver's most charismatic mayors, Gerry McGeer, raised funds to build City Hall in the midst of the Depression. The building was officially opened to celebrate Vancouver's fiftieth birthday in 1936.

OVERLEAF –
Sunshine highlights the North Shore mountains, a striking backdrop to the office and apartment buildings of the West End.

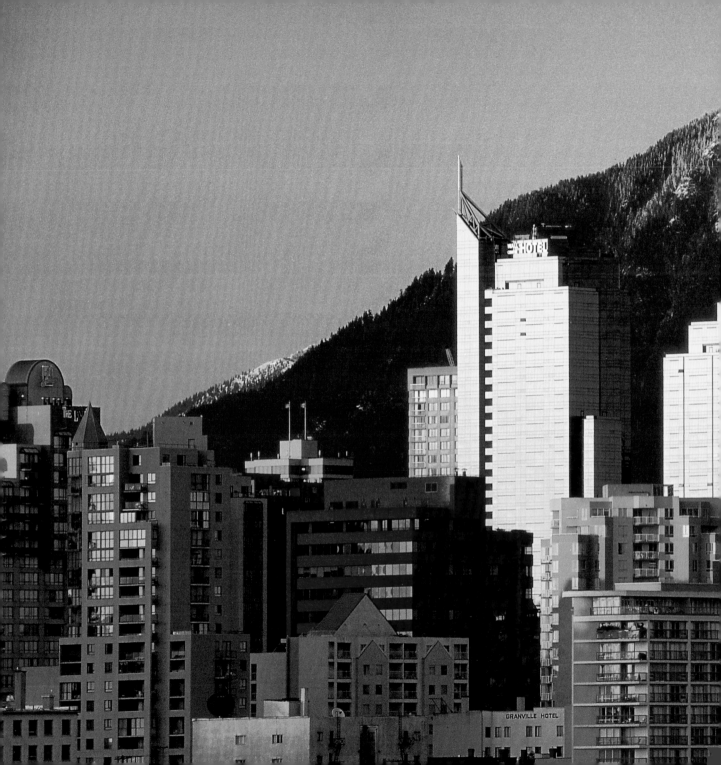

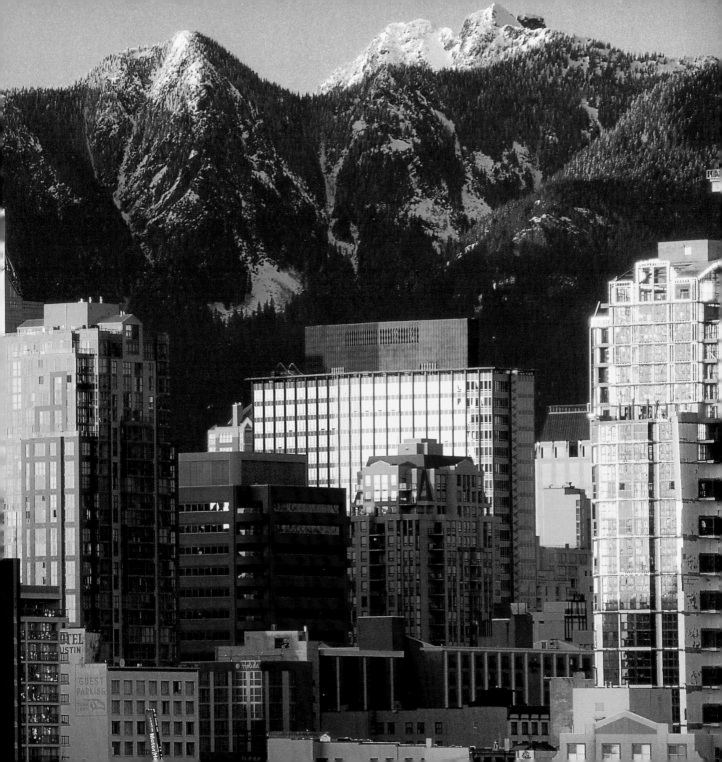

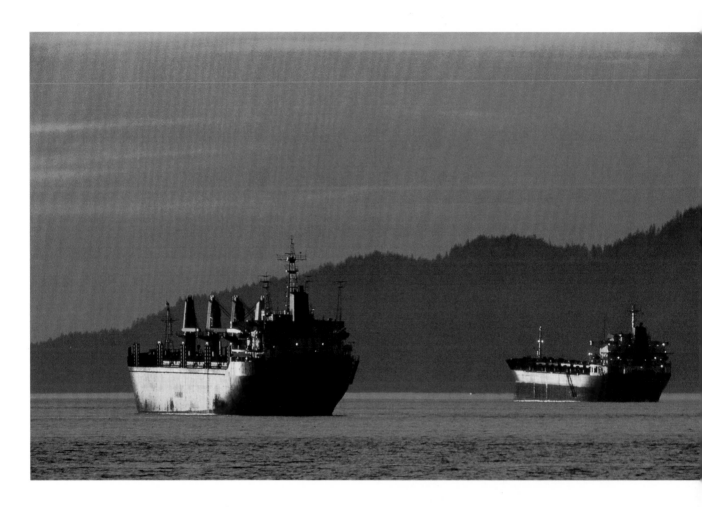

Freighters wait to dock in Burrard Inlet.

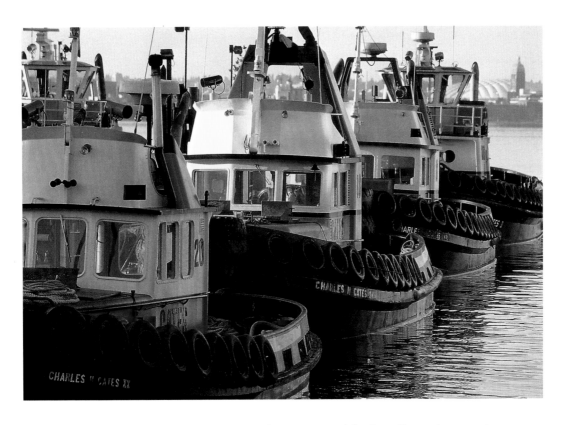

Tugboats at Lonsdale Quay lie ready to service freighters.

Overleaf –
Ships from around the world load and unload in the harbour throughout the year.

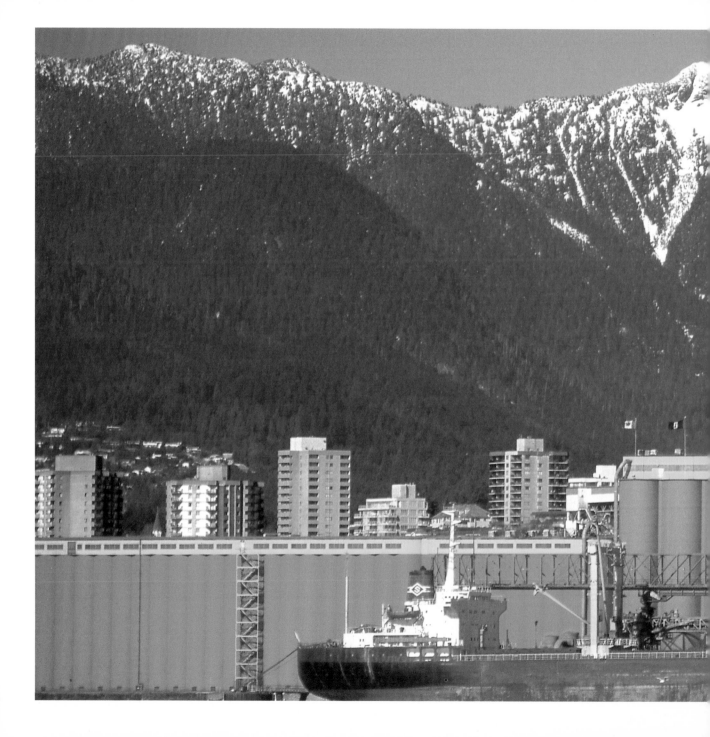

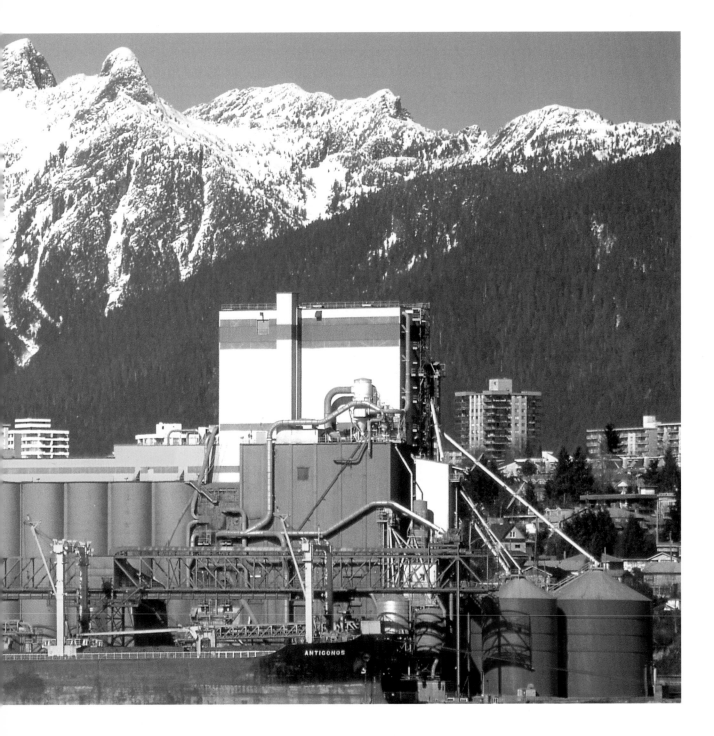

The Capilano
Suspension Bridge
sways a breathtaking
69 metres above the
Capilano Canyon. The
first bridge was built
here in 1889.

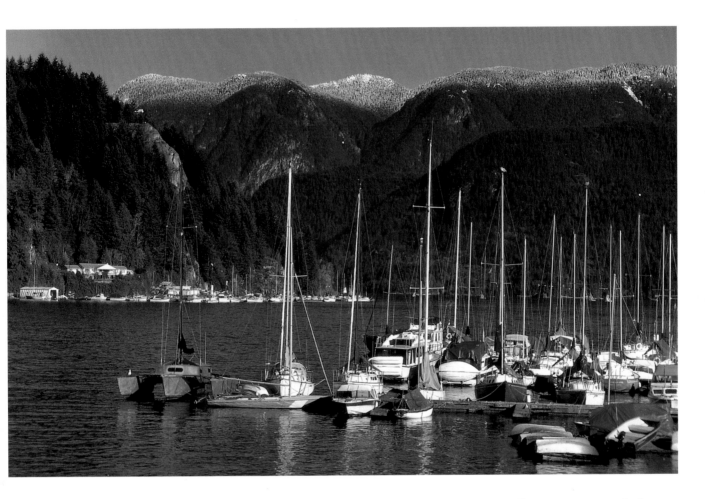

Sailboats and catamarans sway tranquilly at a Deep Cove dock in North Vancouver.

OVERLEAF –
The Point Atkinson lighthouse is part of Lighthouse Park in West Vancouver. The first lighthouse was built on Point Atkinson in 1874. This one is 18 metres and was built in 1914.

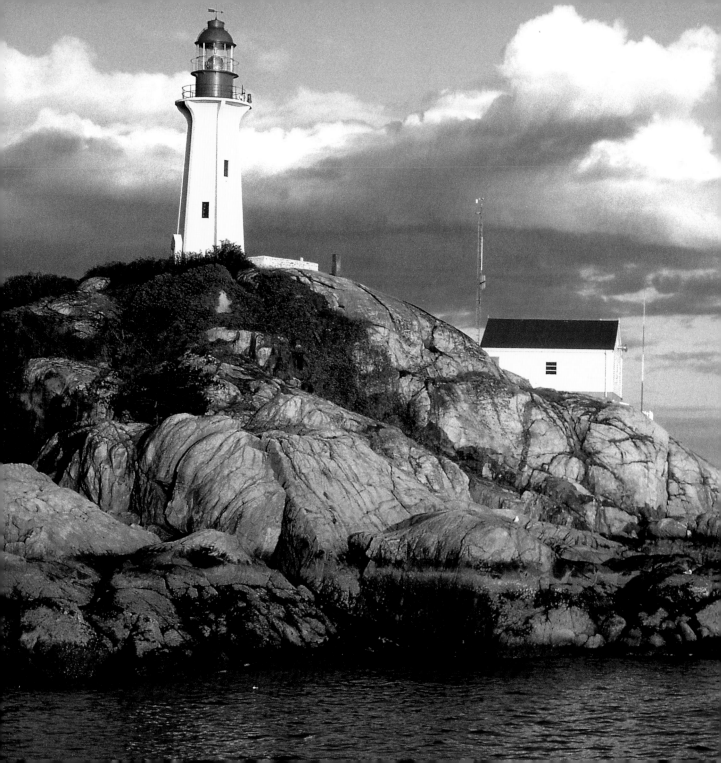

A snowy afternoon prompted these adventurers to escape the modern bustle of the city and enjoy a ride in a horse-drawn sleigh on Grouse Mountain.

FACING PAGE –
The Grouse Mountain Skyride lifts skiers to 1128 metres above the city. In the summer, hikers use the Skyride as a quick way down after climbing the strenuous "Grouse Grind" trail.

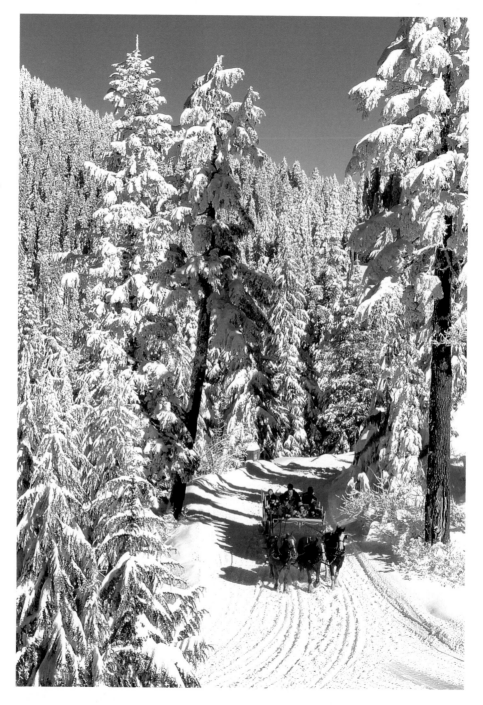

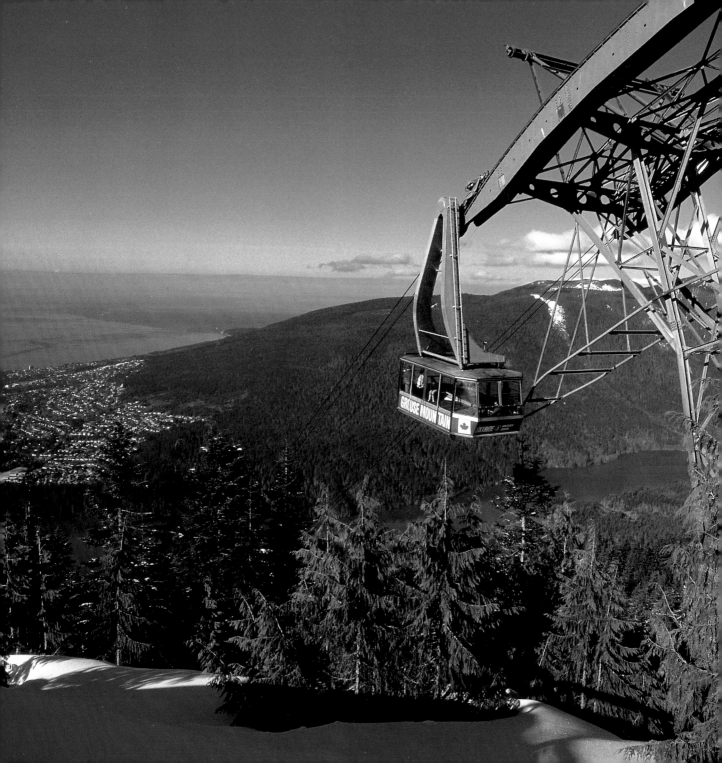

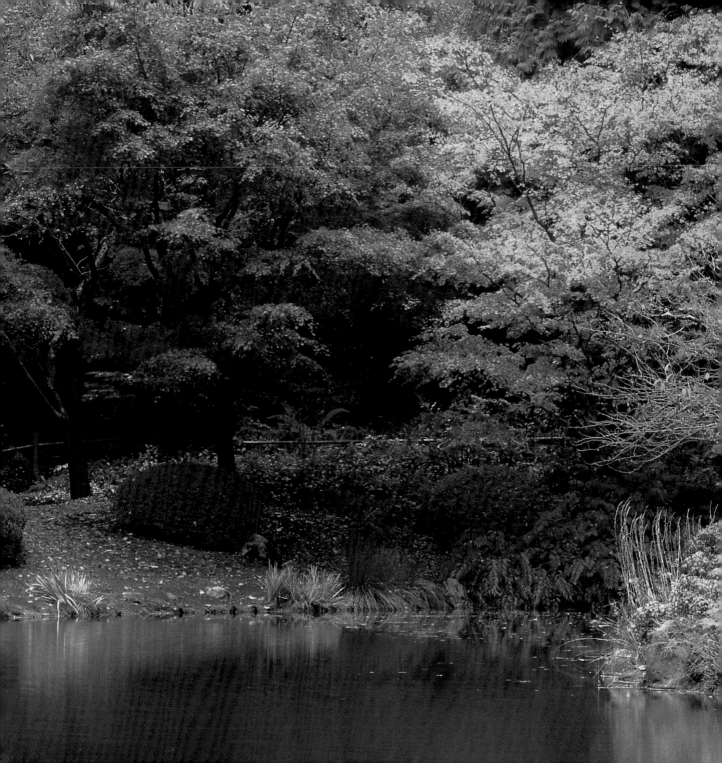

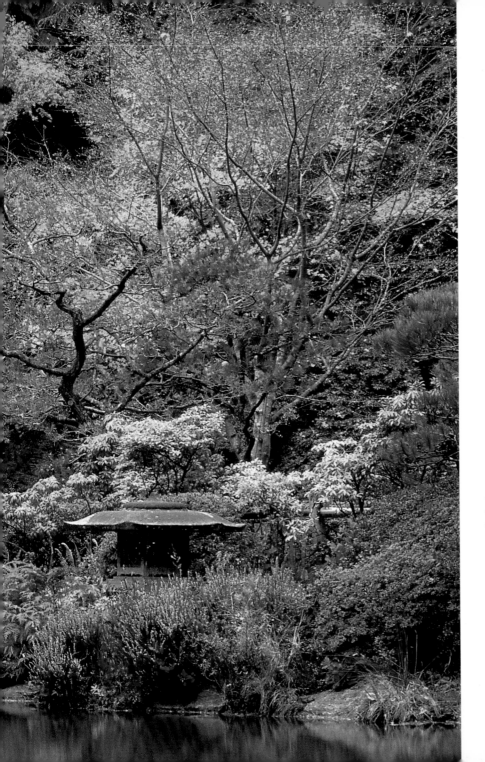

Authentically designed and carefully landscaped, Nitobe Garden was opened at the University of British Columbia in 1960. Its one-hectare expanse features indigenous plants of B.C. as well as those imported from Japan.

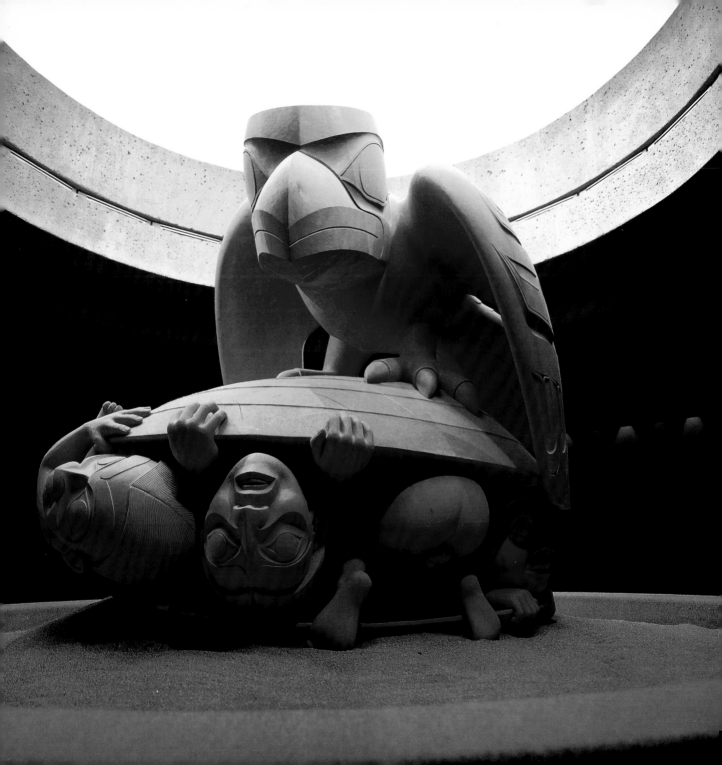

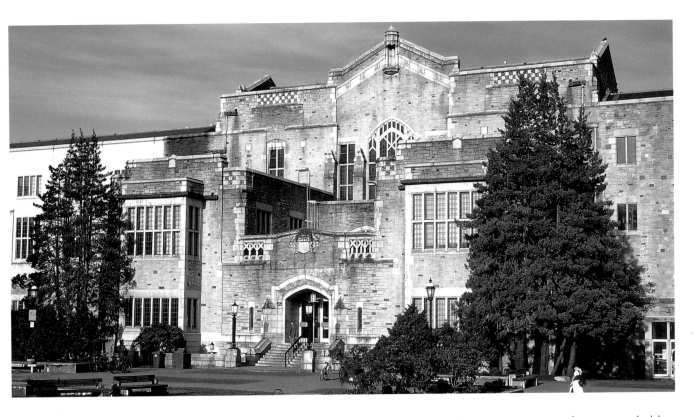

The University of British Columbia was founded in 1908. For years, classes were held in temporary shacks, but due to a massive student protest in 1922, the government granted $1.5 million to build facilities. Permanent buildings and faculties opened their doors three years later.

Bill Reid's stunning cedar sculpture illustrates the Haida story of human creation. *Raven and the First Man* is on display at the Museum of Anthropology, which houses one of the world's finest collections of Northwest Coast First Nations art and artifacts.

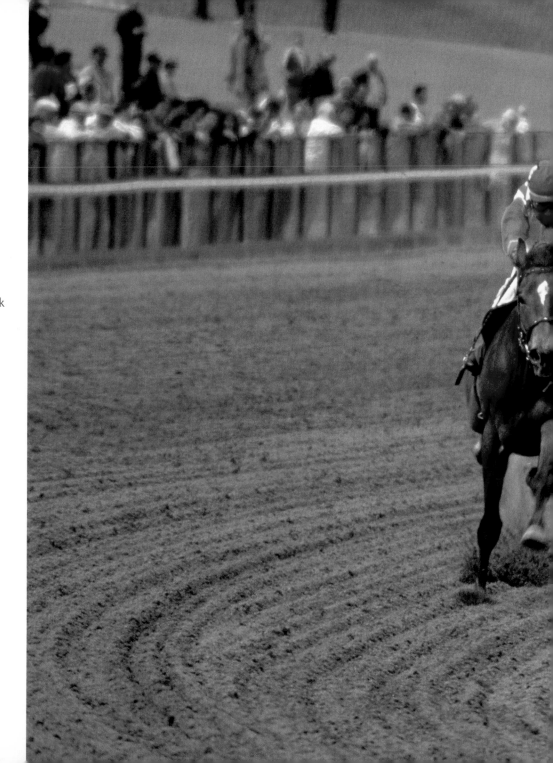

Thoroughbreds
thunder around the
track at Exhibition Park
in East Vancouver.

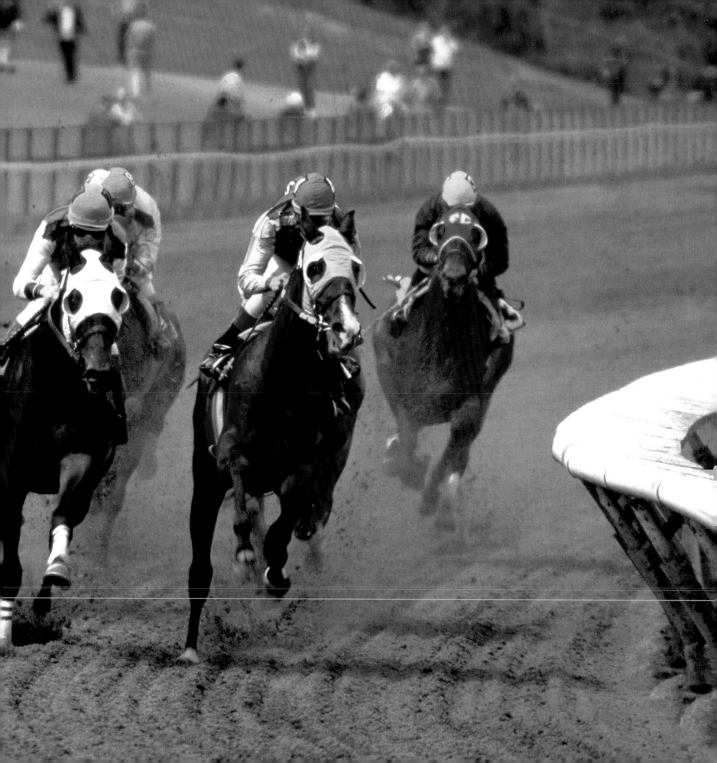

Golfers, cyclists,
walkers, and picnickers
share the quiet and
sunshine at Central
Park in Burnaby.
There's even a small
lake open to remote-
control boats.

FACING PAGE –
One of Vancouver's
two universities, Simon
Fraser is perched high
above the city at the
top of Burnaby
Mountain. It was
designed by Arthur
Erickson, the same
architect who designed
Robson Square and
the Museum of
Anthropology. Simon
Fraser University's first
classes were held in
1965.

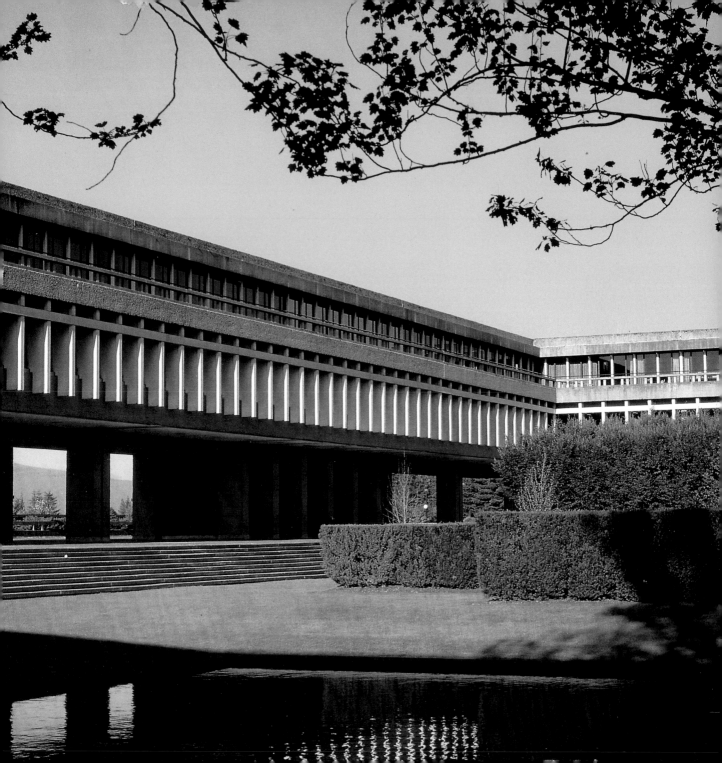

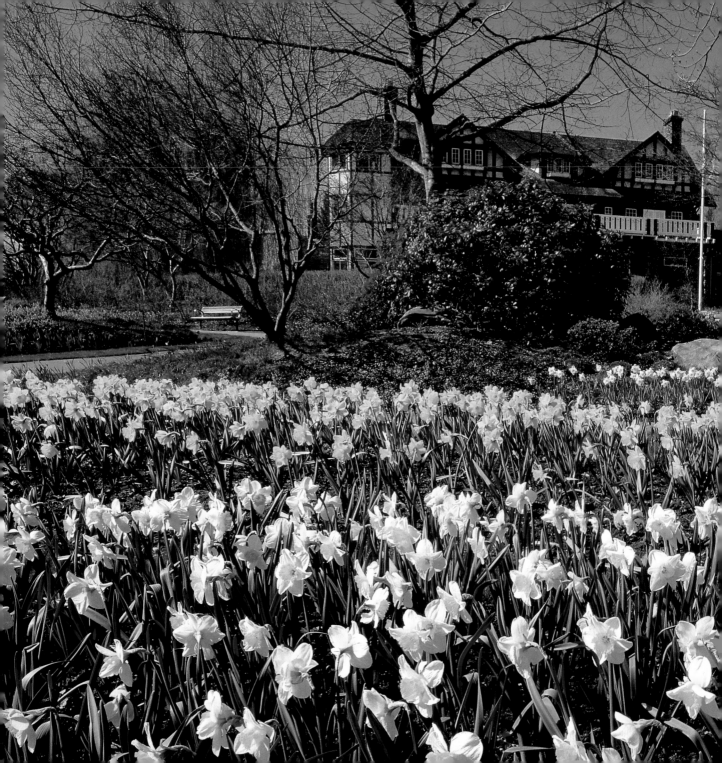

The Burnaby Art
Gallery is housed in
a heritage mansion in
Deer Lake Park.

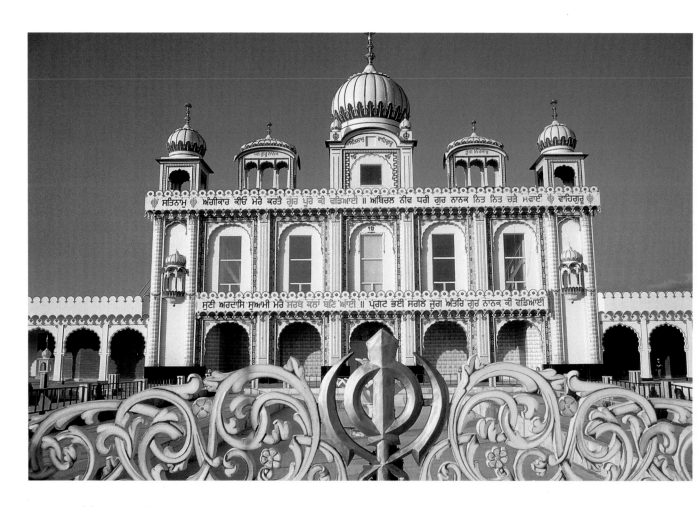

Ornate golden gates give way to
an even more elaborate Sikh temple.

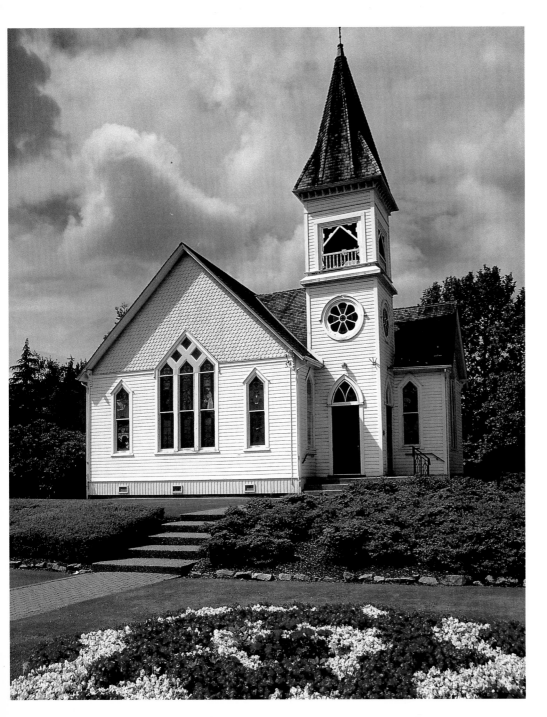

Beautifully landscaped gardens surround Richmond's Minoru Chapel.

OVERLEAF –
The Fraser River Esplanade wanders for two kilometres along the riverbank. These weekend strollers are enjoying the sunshine and sea breezes near New Westminster Quay Public Market.

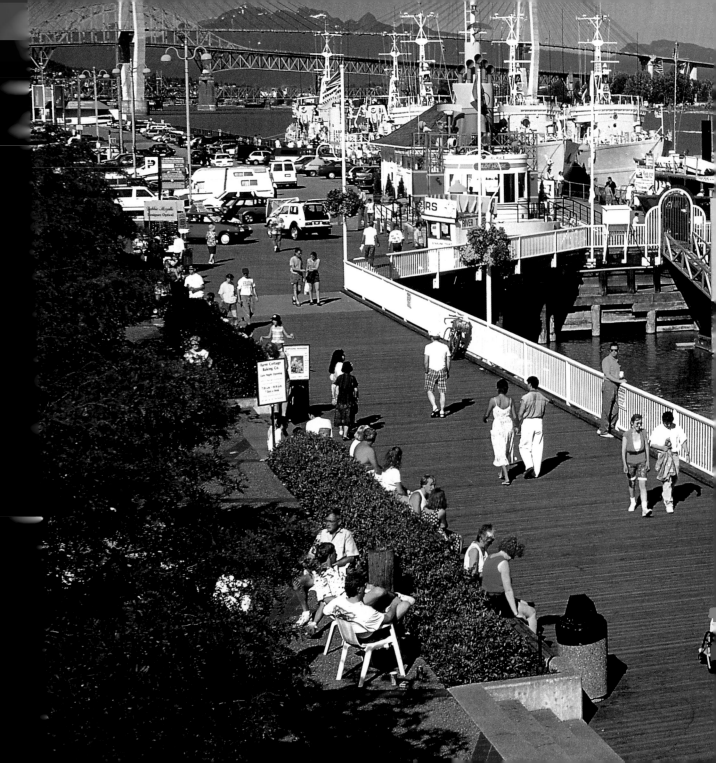

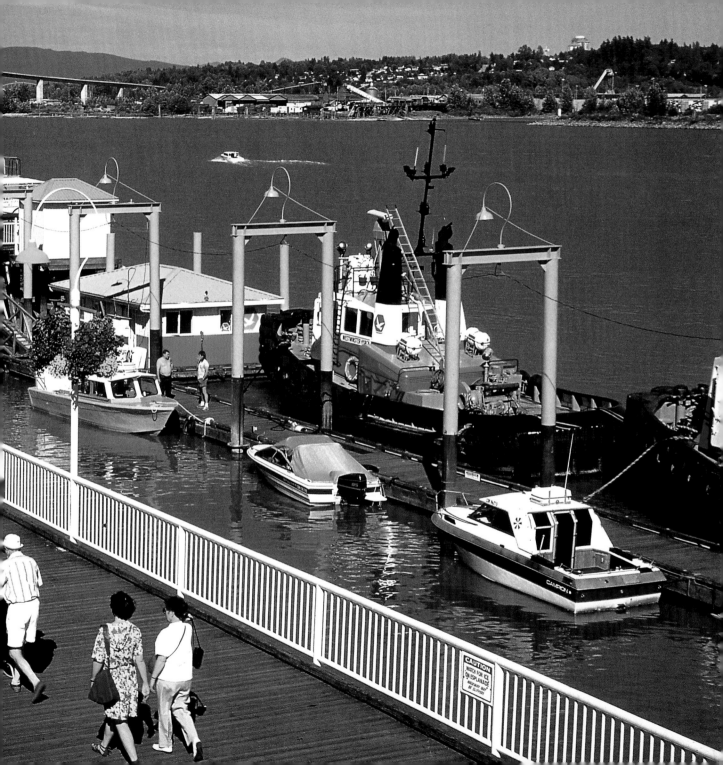

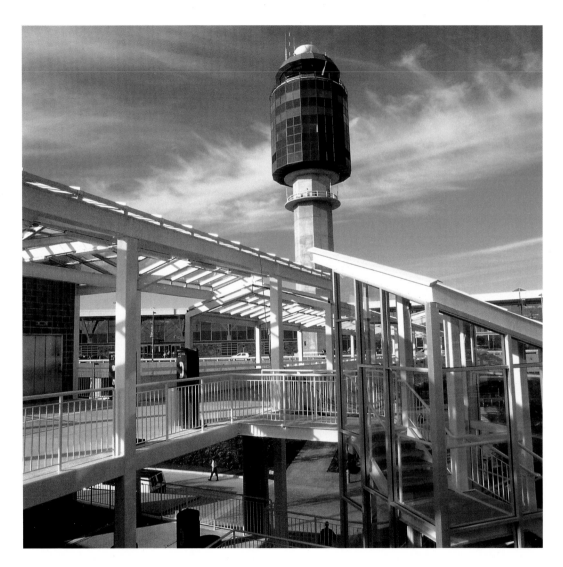

Vancouver Airport's Control Tower and International
Terminal Building opened in 1996. Flights from
Europe, Asia, and the Americas arrive daily.

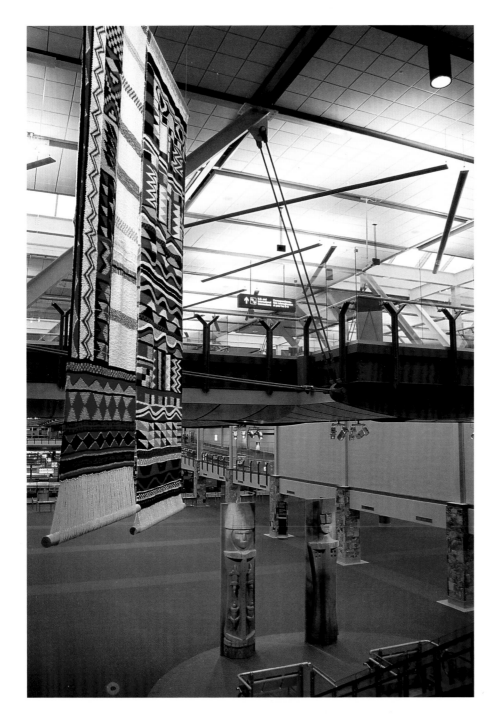

Coast Salish art greets international arrivals at the Vancouver airport. The welcome figures on the lower level are carved in the style of early Salish culture. Crafted from a single pole, figures such as these were traditionally used as house posts. Hanging above, hand-dyed weavings reflect both modern and traditional design.

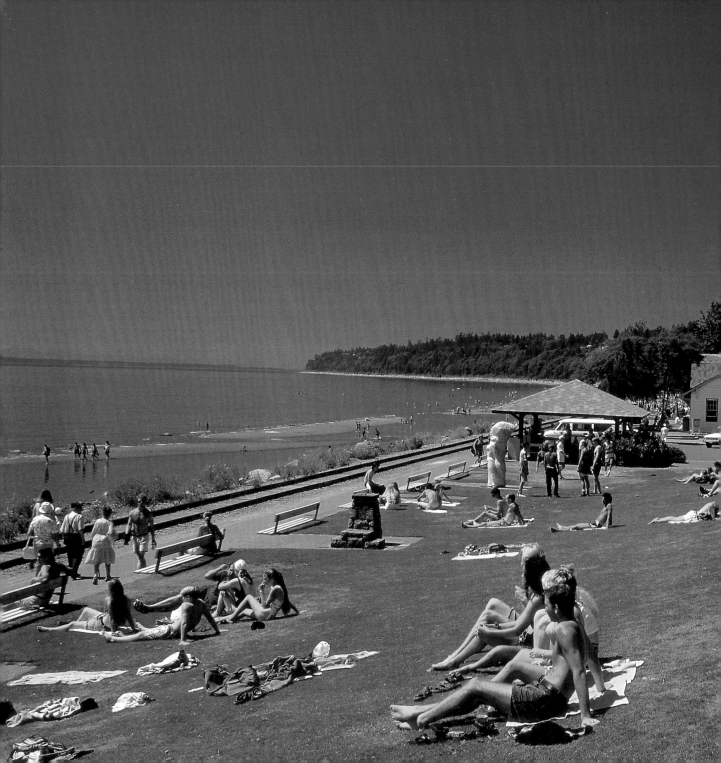

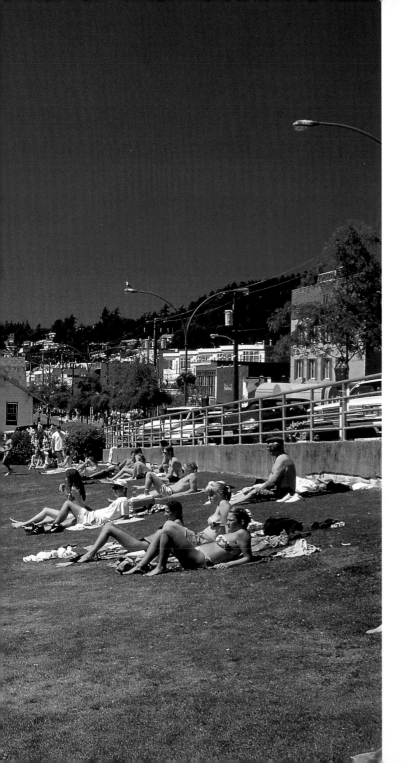

Sunbathers bask on the lawns near the beach at White Rock.

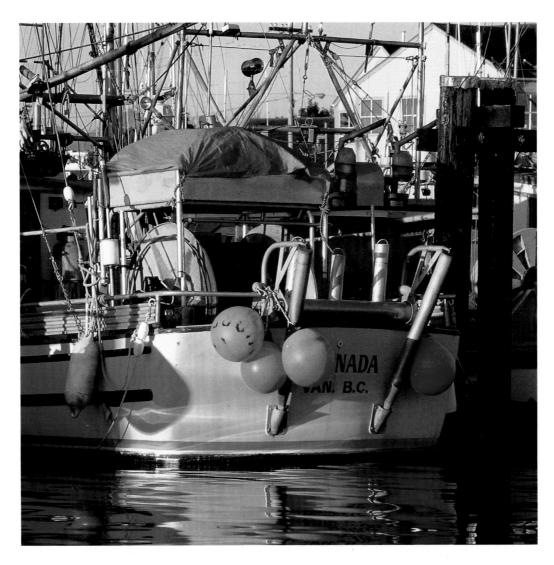

A fishing boat serves as a reminder of Steveston's maritime heritage.
The community grew at the mouth of the Fraser River at a time when the fisheries
were booming. In the late 1800s, thirteen canneries operated along the shore.

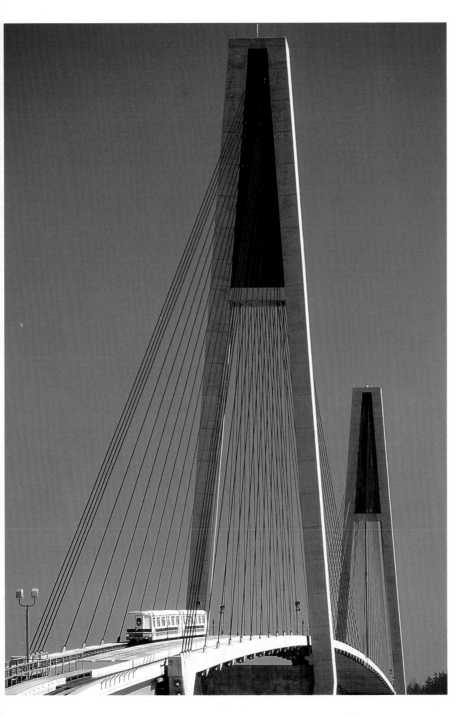

The Skytrain glides over the Fraser River. The first section of the light rapid transit system was built for the 1986 World Exposition. It is computer-controlled, and it was designed using Canadian technology. It now shuttles commuters along some 23.5 kilometres of track between Waterfront Station downtown and the King George Station in Surrey.

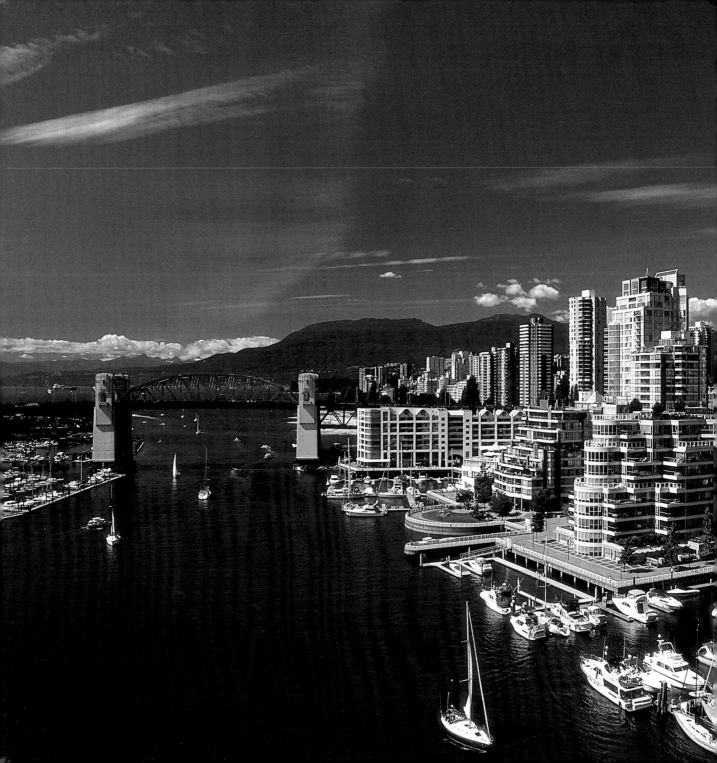

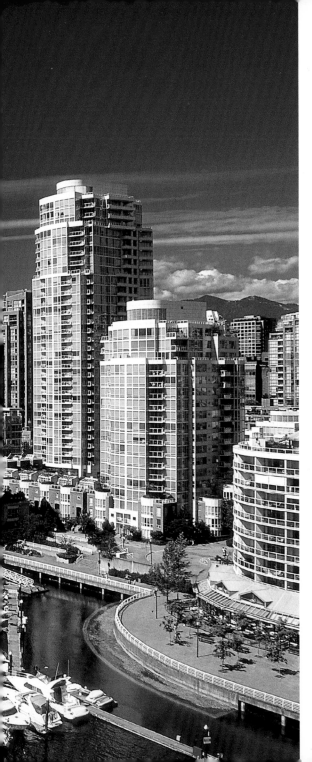

False Creek was named by Royal Navy surveyor Captain George Richards in 1859, when he found his ship in an inlet and not the creek he expected. Once industrial land, the neighbour-hood now hosts hundreds of ocean-view condominiums.

Photo Credits